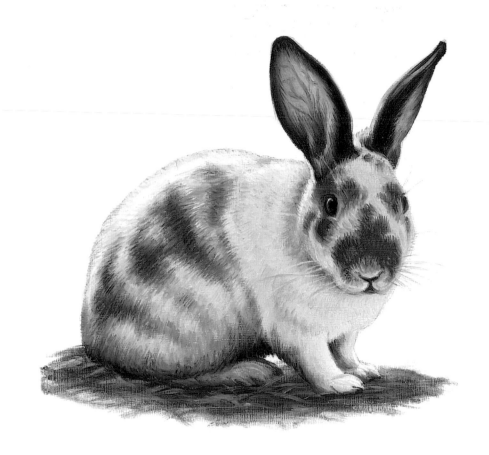

Wildlife
PAINTING BASICS
SMALL ANIMALS

Wildlife
PAINTING BASICS
SMALL ANIMALS

Jeanne Filler Scott

NORTH LIGHT BOOKS

CINCINNATI, OHIO
www.artistnetwork.com

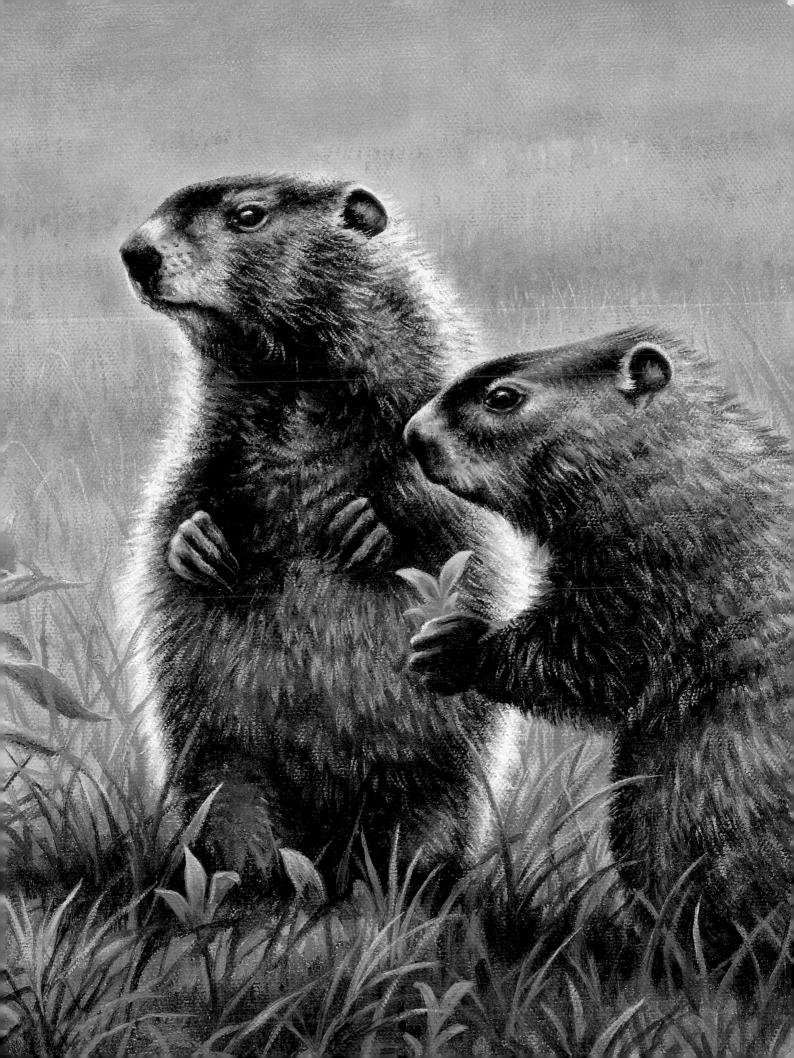

ACKNOWLEDGMENTS

I'd like to thank all the people who have shared their time and their animals with me: wildlife rehabilitators, zoo animal caretakers, pet owners and humane society volunteers. Without their help in getting close enough to the animals so I could observe, sketch and photograph them, this book would not have been possible.

I would also like to thank my editor, Stefanie Laufersweiler, for her help, patience and encouragement. She has been very easy to work with, and very understanding of how overwhelmed I felt about writing and illustrating my first book. Stefanie stuck with me, even when I had a hard time meeting all the deadlines!

DEDICATION

I would like to dedicate this book to: My mother, Janette Brooks Filler, for buying me art supplies, encouraging me to go to art school and sharing my affection for the many pets we kept over the years.

My father, William J. Filler, for his interest in my painting, his helpful critiques of my artwork and for sharing with me, when I was at an early age, his interest in and appreciation for the natural world.

My husband, Tim Scott, for his abundant encouragement and support; his artistic, critical eye in giving me suggestions for improving my painting and for pushing me to push myself to excel in my art; and for his liking and compassion for all sorts of creatures.

My son, Nathaniel Scott, a gifted artist himself, for his helpful comments and suggestions, and for sharing my enthusiasm for art.

And finally, for all the animals I have had the privilege of knowing. They have shown me that emotions, the ability to think and feel and behaviors such as honesty, loyalty and gratitude are not limited to the human species.

Other fine North Light Books are available from your local bookstore, art supply store or direct from the publisher.

06 05 04 03 02 5 4 3 2 1

Library of Congress Cataloging-in-Publication Data
Scott, Jeanne Filler.
 Wildlife painting basics : small animals / Jeanne Filler Scott— 1st ed.
 p. cm.
 Includes index.
 ISBN 1-58180-123-8
 1. Animals in art. 2. Mammals in art. 3. Painting—Technique. I. Title.

ND1380 .S38 2002
751.45'4329—dc21 2001044994
 CIP

Art on page 3: *Whistle Pigs* (detail), oil on canvas, 11" × 14" (28cm × 36cm), collection of the artist

Editor: Stefanie Laufersweiler
Cover Designer: Christine Batty
Interior Designer: Matthew DeRhodes
Layout Artist: Matthew DeRhodes
Production Coordinator: John Peavler

Metric Conversion Chart

To convert	to	multiply by
Inches	Centimeters	2.54
Centimeters	Inches	0.4
Feet	Centimeters	30.5
Centimeters	Feet	0.03
Yards	Meters	0.9
Meters	Yards	1.1
Sq. Inches	Sq. Centimeters	6.45
Sq. Centimeters	Sq. Inches	0.16
Sq. Feet	Sq. Meters	0.09
Sq. Meters	Sq. Feet	10.8
Sq. Yards	Sq. Meters	0.8
Sq. Meters	Sq. Yards	1.2
Pounds	Kilograms	0.45
Kilograms	Pounds	2.2
Ounces	Grams	28.4
Grams	Ounces	0.04

The animal art of Jeanne Filler Scott links painting techniques of the Old Masters with today's knowledge and appreciation of the natural world. When you look into the eyes of one of her animals, you feel the animal looking back at you. "I paint with the understanding that each animal is unique," Jeanne says. "The animal may represent the entire species as an ideal, but on a deeper level, the animal before me is an individual. I try to do justice to my subjects and give their images the vitality and character they deserve."

An interviewer once wrote that the animals in Jeanne's paintings have the "spark of life," and this is certainly true. You immediately sense that her subjects are her intimate friends, and subtleties of their characters find expression in paint only because of long, sympathetic acquaintance.

That sense of life is what Jeanne imparts so well. The intelligent eyes of a wolf follow you around the room. A foal stands in a landscape of early morning mist, undecided whether to take a lump of sugar from your hand or break into a youthful gallop. In a peaceful wood, you relax with a red fox as he indulges in a satisfying stretch and contented yawn. Jeanne's paintings are celebrations of life.

Jeanne's work has appeared in many exhibitions, including the Society of Animal Artists, Southeastern Wildlife Exposition, National Wildlife Art Show, MasterWorks in Miniature, NatureWorks, Nature Interpreted (Cincinnati Zoo), American Academy

Jeanne with Sasha.

of Equine Art and the Kentucky Horse Park. Several of her paintings have been published as limited edition prints, two of which are sold out.

Jeanne's paintings have been published on greeting cards by Leanin' Tree, and she has been featured on the covers and in articles of several magazines, including *Equine Images*, *Wildlife Art News* and *Chronicle of the Horse*. Her work has been included in the books *The Best of Wildlife Art* (North Light Books, 1997), *Keys to Painting: Fur & Feathers* (North Light Books, 1999) and *The Day of the Dinosaur* (Bison Books, 1978), which was later re-released as *The Natural History of the Dinosaur*.

She is a member of the Society of Animal Artists and the Lexington Art League.

Jeanne and her family live on a farm in Washington County, Kentucky, surrounded by woods, fields and the Beech Fork River. Many kinds of wild creatures inhabit the farm, including wild turkeys, deer, raccoons, opossums, woodchucks, foxes, coyotes, box turtles, squirrels and cottontail rabbits. Their animal family includes six dogs, eleven cats, two chickens, three iguanas, eight horses, seven cows, two hamsters, two gerbils and two Dutch rabbits. See more of Jeanne's work on her Web site at www.jfsstudio.com.

table of contents

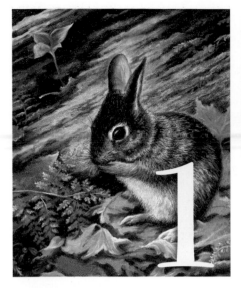

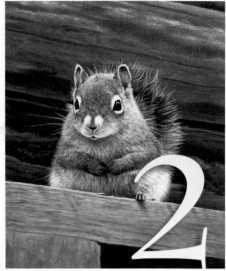

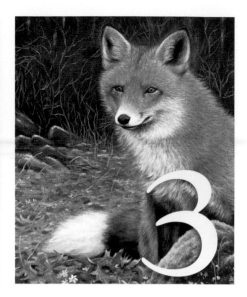

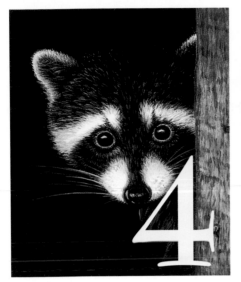
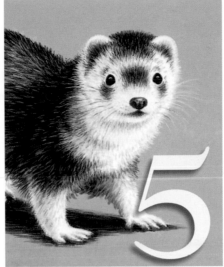
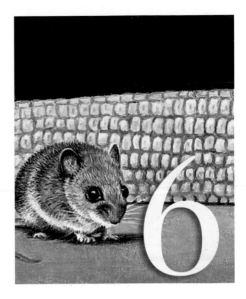

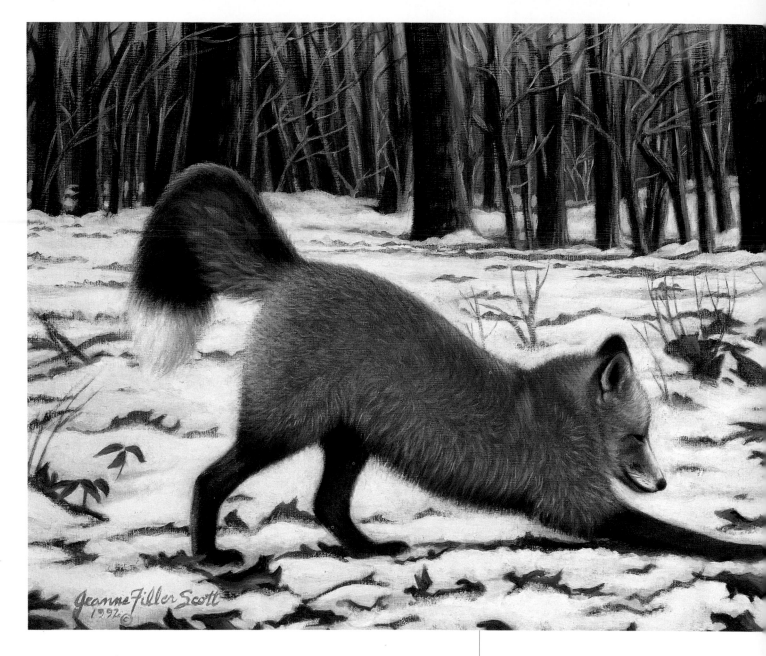

A Foxy Stretch I
Oil on panel
8¼" × 13½" (21cm × 34cm)
Private collection

introduction

This book is intended for the artist who is interested in portraying small animals, specifically mammals. Although I could not include every kind of small mammal—for example, there are fifty-two species of rabbits and hares—my goal was to give you a sampling of some of the better known smaller mammals. I've chosen both wild and domestic animals that are familiar to many people.

You'll learn the basic traits of each animal, and how they differ from other kinds of animals. Also, within each species, I've tried to use more than one individual of each kind of animal as models, so you can see the differences between them. When you aren't familiar with a group of animals, you tend to think they all look alike, but, when you get to know them, they are as different as people.

When painting animals, the most important thing you should strive to capture is the personality of that particular animal. However, before you can aspire to this goal, you need to understand the animal's basic anatomy. This book will help you with the small details that are so often hard to remember when the animal you want to paint is no longer in front of you, and often hard to see in reference photographs.

The step-by-step demonstrations will show the techniques you can use to portray the animal realistically. I have tried to tell you everything I can to eliminate a lot of the trial and error I had to go through to learn how to paint this way.

I hope you will enjoy and learn from this book, and be inspired to create your own works of art portraying small mammals.

Materials

The mediums included in this book are oil, acrylic, gouache and pencil. The following pages contain information and tips for surfaces, paints, brushes, pencils and accessories for painting and drawing.

Surfaces

Canvas—Canvas is a good surface for acrylic or oil paintings. You can buy canvas as panels or as stretched canvas. I don't recommend the canvas panels, as they are usually cheaply made and roughly textured. When buying stretched canvas, look for the portrait grade rather than the coarser grade, as it works much better for detailed, realistic painting. I prime my canvas with acrylic gesso before painting.

Masonite Panels—You can buy untempered Masonite (also called hardboard) either in large sheets at a lumberyard to cut into smaller pieces yourself, or you can buy precut Masonite panels in a variety of sizes. The advantage of buying the large sheets and cutting it yourself is that it is much less expensive than buying precut panels. I prime the panels myself with acrylic gesso. Gessobord, a preprimed version, has a nice texture but it's more expensive, of course. I've tried other brands and have found their surfaces to be either too slick or too absorbent.

Illustration Board—Illustration board is a good surface for acrylic, gouache and pencil. It comes in two basic types: cold press, a lightly textured surface good for acrylic, gouache and pencil; and hot press, which has a very smooth surface that's good for pencil drawing. Illustration board varies in thickness and permanence. The high rag content boards are the most per-manent. These boards come in various sizes, depending on the manufacturer, but you can buy large sheets and cut them to any size.

Bristol Board—Bristol board is a good surface for pencil, and it can be used as well for acrylic and gouache paint-ing. It comes in different thicknesses, either as a separate board, or in a pad of two-ply sheets, which are like stiff, extra-heavy paper. It comes in a vel-lum finish (cold press) and a plate fin-ish (hot press). The vellum finish is more textured and is good for acrylic, gouache and pencil, while the plate finish is good for finer pencil work.

Brushes

For my detailed, realistic style of painting, I use almost all sable or synthetic sable brushes, rather than the rougher bristle brushes. Although I own a few sable brushes I prefer the synthetic fiber brushes, as they are more durable than real sable and are less expensive. Also, I feel better knowing no animal was harmed in manufacturing them.

Rounds are best for fine detail, as they come to a point. Filberts are good for covering larger areas, and since they are tapered, can be easily manipulated around contours. Flat brushes are good for very large areas such as skies.

I use the same brushes for acrylic painting that I use for oils. You will need to have two to four of each type of the brushes you'll be using a lot, such as no. 1 and no. 3 rounds. As you'll see in the demos, you'll often need two or sometimes three of the same sized brush with different colors, so you can alternate one with another.

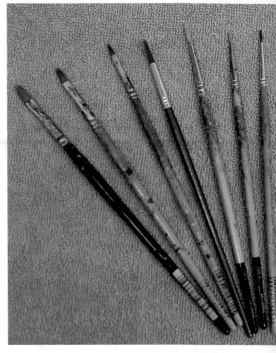

These are the brushes I use most frequently (from left): nos. 6, 4 and 2 filberts, and nos. 5, 3, 1 and 0 rounds. Most of these brushes are made of synthetic sable. Some of the brushes that look like sable are actually Golden Taklon, a synthetic sable brush that is stained to look like sable.

Tip

Have several of each of the brushes you use a lot on hand, such as no. 1 and no. 3 rounds. Then, while painting, you can keep one brush for each color you are using. When you need to blend one color into another, you won't have to clean a brush each time you change colors. This will save you time and make working on your painting smoother and more enjoyable.

What You Need for Acrylic Painting

Surface—For acrylics, you can paint on a variety of surfaces, including canvas, Masonite, illustration board and bristol board.

Paints—The acrylic colors I use the most are Burnt Sienna, Burnt Umber, Cadmium Orange, Hansa Yellow Light, Payne's Gray, Raw Sienna, Scarlet Red, Titanium White, Ultramarine Blue and Yellow Oxide. I recommend buying good quality rather than student-grade paints because the color saturation will be higher and your artwork will be more permanent. Acrylics come in tubes and jars, and both are fine to use.

Palette—While I've not yet found the perfect method for keeping acrylic paints from drying up while painting, the Masterson Sta-Wet Premier Palette is a big help. It consists of a 12" × 16" (30cm × 41cm) plastic box that is 1¾" (45mm) deep, and comes with a sponge insert which, when wet, fills the bottom of the box. A special disposable paper called Acrylic Film, which is discarded after it is used up, sits on top of the sponge insert. The box has an air-tight lid.

The directions that come with this palette tell you to saturate the sponge with water and explicitly say not to wring out the sponge. However, I found that if I didn't press out some of the water, my paints turned into a runny soup after a short time. After a few days, my acrylics would start to dry out due to the sponge drying underneath. To fix this, I took a spray bottle and lightly sprayed the paints with water, then sprayed both the sponge and the underside of the paper enough to wet it evenly. I repeat this whenever necessary.

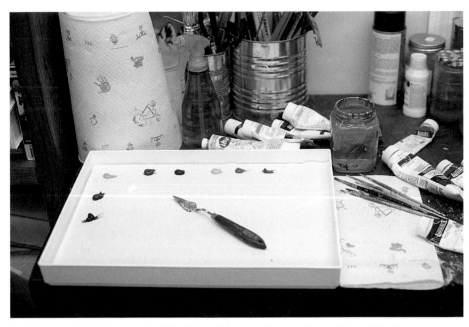

I prefer to use the Masterson Sta-Wet Palette (shown) when working with acrylics. It is a great help in keeping my paints from drying out as I'm working.

Jar of Water—Water is the only medium I use for thinning my acrylic paints. When your water becomes murky with paint, change it.

Paper Towels—Paper towels are useful for blotting excess paint or water from your brush. Keep a folded paper towel by your palette.

Palette Knife—You'll need a palette knife for mixing your paints. A tapered, steel knife works best, and the trowel type (rather than the straight) where the handle is lifted above the blade is the easiest to use. Be sure to clean your palette knife between colors. Wiping it on a paper towel usually is sufficient, but occasionally you'll need to dip it in water.

No. 2 Pencil and Kneaded Eraser—The no. 2 pencil is for drawing the subject onto your canvas or panel. You can do this directly, but it is better to do your drawing on a piece of paper first. Then you can make any corrections on the paper rather than

on your painting surface. It also gives you more flexibility with the placement of your subject, because after you have drawn it you might wish you could move it.

The kneaded eraser is good for making corrections, or for lightening pencil lines on your painting surface so they won't show through the paint later on. This type of eraser comes in a flat square package. Before using it, knead it with your fingers until it looks like a small lump of clay. To clean the eraser, stretch it out and work it around until it is no longer covered with pencil graphite.

What You Need for Oil Painting

Surface—For oils, you may use either canvas or panel.

Paints—The oil colors I use most are Burnt Sienna, Burnt Umber, Cadmium Orange, Cadmium Red Light, Cadmium Yellow Light, Payne's Gray, Raw Sienna, Titanium White, Ultramarine Blue and Yellow Ochre. As with acrylics, I would recommend buying a professional brand rather than the student-grade paint.

Medium—This is what you dip your brush into before dipping it into the paint. It makes your paint flow more easily and allows you to create different effects, depending on how much medium you use. The medium I recommend is Winsor & Newton Liquin. It not only does an excellent job of thinning the paint, it also speeds up the drying time—but the paint still stays wet long enough for you to take your time blending. It is a durable, non-yellowing medium and is great for glazing.

Palette—The most convenient paint holder is the disposable palette, which consists of a pad of waxy sheets of paper that you tear off and discard when you are finished with them. Disposable palettes come in 9" × 12" (23cm × 30cm) and 12" × 16" (30cm × 41cm) sizes. I recommend the larger size so you don't run out of space for mixing your paints as quickly.

There are several manufacturers that make covered plastic boxes that are designed so that a palette pad can fit inside. These are good for protecting your paints and keeping them from drying out too quickly.

Palette Knife—The same kind of palette knife works well for either oils or acrylics: a trowel-type knife with a tapered blade. Keep separate palette knives for your oils and acrylics.

Paper Towels—Fold a paper towel to double its thickness and place it next to your palette. This will serve as your brush blotter—to remove excess turpentine after you have cleaned your brush or to wipe off excess paint or medium, and to clean your palette knife. Keep another paper towel handy for wiping a brush or cleaning unwanted paint from your canvas. Change your paper towel as soon as it gets saturated with paint or turpentine.

Paint Thinner/Brush Cleaner—Turpentine or turpentine substitute is good for cleaning your brushes between colors and at the end of your painting session. It is also used to thin your paint when you're sketching the basic lines and values over your pencil sketch. Keep the jar covered when not in use to avoid breathing excess fumes.

No. 2 Pencil and Kneaded Eraser—These materials, used for sketching or transferring your sketch to your painting surface, are used in the same way whether you are doing an oil or acrylic painting.

Cleaning Your Oil Painting Brushes

If I have just used my brushes for oil painting and am finished for the day, I clean the brushes first with turpentine, then with a special soap called ACMI Brush Cleaner and Preserver. This soap comes as a hard cake in a plastic container. You wet the brush and work up a lather, then rinse the brush out with water. If paint has dried on your brush, you can leave the lather on longer and rinse it out later. You may have to do this several times, but you can often reclaim a valuable brush this way.

What You Need for Gouache Painting

Surface—Good surfaces for gouache painting include illustration board and bristol board.

Paints—The gouache colors I use most are Burnt Sienna, Burnt Umber, Cadmium Orange, Cadmium Red Pale, Cadmium Yellow Deep, Spectrum Yellow, Ultramarine Blue, Yellow Ochre and Zinc White. I recommend that you buy high-quality colors rather than student grade.

Palette—While the Masterson Sta-Wet Palette works fairly well with acrylics, I found it to be less satisfactory with gouache. The paint tended to become very runny, even if I squeezed some of the water out of the sponge. I found the best way of doing it is the way I've always done it: Use an ordinary disposable palette pad and a spray bottle that atomizes water into a fine mist. Whenever the paints begin to dry out, spray them lightly.

Jar of Water—The thinner for gouache paint is water. Keep a clean jar of water by your palette.

Palette Knife—Use the same kind of palette knife for gouache as you would for oil or acrylic painting—the steel trowel type with a tapered blade. You can use the same palette knife for your acrylics and your gouache paints.

Paper Towels—It is important to have a paper towel, folded to double thickness, next to your palette for blotting your brush. You need to blot your brush after you have cleaned it to remove the excess water, and also to remove some paint when you have too much on your brush.

No. 2 Pencil and Kneaded Eraser—These are used for sketching or transferring your sketch to your painting surface.

What You Need for Pencil Drawing

Surface—Good surfaces for pencil drawing include illustration board and bristol board. The hot-press or plate finish is good for very finely detailed pencil work, whereas with the cold-press or vellum surface, you'll have more of a "tooth" or grain, which will give you a different effect in your drawings.

Pencils—Use a no. 2 pencil for your preliminary, underlying sketch, whether you're sketching directly on your final surface or transferring your sketch.

For your finished drawing, I recommend the Ebony pencil. Have at least two of these pencils on hand while working on your drawing, sharpened to a fine point. When I am doing a major pencil drawing, I usually have a dozen presharpened Ebony pencils on hand. When one gets dull, I simply switch to the next.

To keep your pencil sharpened, it is very helpful to have an electric pencil sharpener in your studio. Have a piece of fine-grade sandpaper on hand also. Rub the point of the pencil sideways with a rolling motion to create a very fine point.

Kneaded Eraser—The kneaded eraser is the best kind of eraser for pencil work, as it erases cleanly and can be kneaded into any shape. If you need to use it in a very small area, you can form the eraser into a point. Also, it is easily cleaned by kneading and working it around as if it were a ball of clay.

Blending Stump—Blending stumps and tortillons are used for blending and smoothing. They are made of tightly spiral-wound, soft paper. Although I have always used these terms interchangeably, one art supply catalog I referred to defines stumps as being longer than tortillons, pointed on both ends, and used for blending large areas. Tortillons are shorter and pointed only on one end, and are used for more detailed blending.

I have used tortillons in some of the pencil demos, but not in all of them. They are a good tool for blending and give a different look to your drawing than using just the pencil to blend. Both methods can produce dynamic drawings.

Other Useful Studio Accessories

Mahlstick—This is a rod that you push against your easel, and is held an inch or so from the surface of your painting so you can rest your hand on it instead of on the wet painting. This is especially useful for oil painting, where the paint dries slowly.

Brush Holder—You can make a brush holder by attaching a clamp to a small can and clipping it to your easel for convenient access to your brushes.

Mirror—It is useful to view your painting or drawing in a mirror. This will allow you to see the artwork from a different perspective, and any distortions will immediately pop out.

Picture Clamps for Your Easel—Clamps attached to your easel can hold reference photos, freeing up your hands for painting.

Magnifying Glass—A magnifying glass is great for holding up to your reference photo so you can see the details better. You can either have one that is attached to your easel (some even have a light) or use the handheld type.

Extra Light—In addition to having good lighting in your studio, it is very helpful to have a light right beside your easel. I use a halogen floor lamp not only for extra light on my painting, but also for seeing more detail in my reference photo.

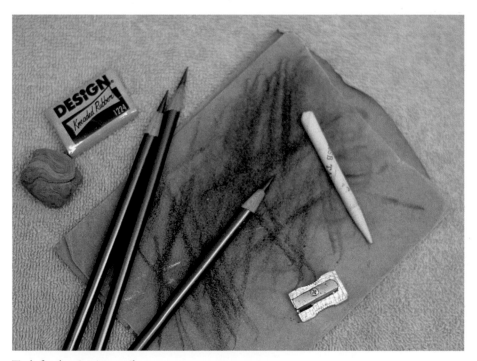

Tools for drawing in pencil.

Finding Animals for Reference

There are several different ways of gathering references for your artwork. The artist who portrays animals should get to be as familiar as possible with his or her subjects.

Locating Subjects

Small mammals are relatively easy to find, but wild animals such as cottontail rabbits and woodchucks aren't always easy to approach closely enough to observe, sketch and photograph. Here are some places to find wild animal subjects.

Zoos—Zoos are good places to see a wide variety of animals. If you are patient, you can get some great reference photos at zoos. Some more modern zoos have the animals in naturalistic settings, which are much better for the animal and also for the artist because they may help you place the animal in a more natural setting in your painting. If you talk to the zoo employees and tell them you are an artist, they will often help you out, even giving you a private showing of the animal you're interested in. Zoos are also a great place to sketch animals from life.

Parks—Parks and places where animals such as squirrels are fed and protected—and have lost much of their fear of people—can be good places to see small animals up close. My best gray squirrel references were obtained on the University of Kentucky campus, where the squirrels see lots of people and are often fed by the students. National parks such as Yellowstone National Park in Wyoming and Banff National Park in Canada, where hunting is not allowed, provide wonderful close-up wildlife viewing.

Wildlife Rehabilitators—Wildlife rehabilitators take in injured or orphaned wild animals and try to rehabilitate them so they can be returned to the wild. If the animal cannot be returned to the wild, they often provide a home for these animals. I have found these people to be very friendly and helpful. They don't get the credit they deserve for all the good work they do, and they are usually happy to share their animals with people who are interested in them.

Veterinary Clinics—Veterinary clinics that take in wildlife and/or treat small domesticated animals can be approached for references. Some veterinarians volunteer their services to help wild animals in need, giving them emergency care and then turning them over to a wildlife rehabilitator.

Hiking Trips—While hiking in the country or the woods, always carry your camera in case an opportunity arises. You never know when you might happen upon an animal that is as surprised as you are at the encounter!

Domestic animals are easier to find; following are some common sources.

Pet Owners—If you want to paint a ferret, for example, ask your friends if they know anyone who has one, or call your local humane society or veterinary clinic for a referral. Most pet owners are proud of their animals and will gladly allow you to photograph them, especially if you give them copies of the pictures.

State and County Fairs—County fairs are often a good place to see a variety of domestic animals such as rabbits. You can sketch and photograph them at your leisure. If you talk to the people who raise the animals, you have a good chance of being invited to their home to see the animals in a quieter setting.

Humane Societies—Humane societies often have small animals such as rabbits, hamsters and gerbils for adoption. If you can't adopt them yourself, most humane societies will allow you to observe these animals, especially if you make a small donation or volunteer some help.

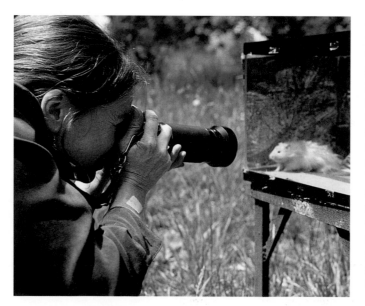

A good way to photograph small animals such as hamsters, gerbils or mice is to put them in a ten-gallon aquarium with a piece of cardboard on the bottom for the animal to walk on, and a tight-fitting lid. Take the aquarium outside so you don't need to use a flash (which would reflect off the glass) and photograph the animal through the glass.

Taking Reference Photos

Camera Equipment You'll Need

For basic photography, you will need a 35mm camera with a normal lens and a telephoto zoom lens. The zoom lens is very valuable for animal photography because it can be quite difficult to get close enough to your subject. Also, the zoom lens allows you to choose how you frame your subject. The normal lens may be used if you can get really close to the animal (a domestic animal, for instance) and it may be used for photographing backgrounds.

I generally use print film balanced for daylight: ASA 200, which is better for bright sunny days or ASA 400, which is better for overcast days. Not as much light gets into the camera with a telephoto lens, so unless you have a situation with a lot of light, ASA 400 film is best.

The following are other accessories that are useful, but not absolutely necessary if you are on a limited budget:

Motor drive. This device allows you to take photos more quickly, as you do not have to stop and advance the film by hand each time.

Polarizing filter. This fits over the lens and cuts down on glare. For instance, if you were looking down into a pool of water to photograph otters, it would allow you to see into the water much better. On bright, sunny days, a polarizing filter cuts down on haze and intensifies colors.

Tips for Photographing Animals

Photography is a great tool for the animal artist. Animals move constantly, and while you'll be able to capture only a few lines with a sketch, photo-graphs can preserve the moment in great detail. This gives you much more information to work from, and more flexibility as an artist. However, there is more to animal photography than pointing the camera and pressing the shutter release. Learning to take good photographs is a skill that comes with practice.

Here are a few tips:

Get down to the animal's level. Many beginners take pictures of animals while looking down on them, which may distort your perception of the animal's form. (Sometimes looking up at an animal is appropriate, such as a squirrel in a tree, since that is where they are often seen.)

Take several rolls of film. The more photos you take, the more likely you are to get a really good pose. You never know when you'll get the chance to photograph that kind of animal again.

Take some close-up pictures of the animal's features. These kinds of photos can really be helpful, as sometimes these details are hard to see in photos showing the entire animal.

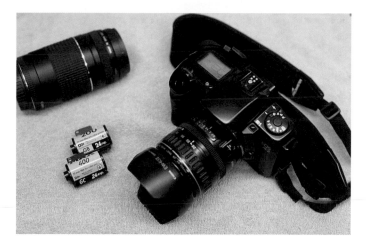

A 35mm camera with a telephoto zoom lens and appropriate film are all you need to get started photographing animals.

Background Photos

In the excitement of photographing an animal, you may fill up your frame with the animal and forget about the animal's setting. If the animal is in its natural habitat, take advantage of the opportunity to capture some of the environment.

When you are walking in the woods, look for things that would look nice in a painting, such as toadstools, ferns and mossy logs. Take close-up photos of weeds and grasses in a field. Be sure to get down to the level of the subject you would paint into the scene. Keep these photos on file.

You can combine elements from different photos for use in a painting. When using more than one photo-graph—and you have a strong light source in your main reference photo—be sure that you paint the background elements so that all light is coming from the same direction. If all your photos were taken on a bright overcast day (which is the lighting preferred by many photographers), you don't have to worry about the light source.

Working From Photos, Life and Other Resources

Working From Photos

When artists work from photos, it is usually not their intention to make their painting look just like a photo. A good painting improves upon the images captured in reference photos because the artist can create a composite image with the best details from various photos. In my work, I strive to make my paintings look better than a photo—I want my paintings to come as close as possible to being there and seeing the animal alive and breathing.

Keeping Photo Files—Always take advantage of opportunities to photograph animals for your files. Even if you have no immediate use for the photos, you never know when you will be called upon to paint a mole, for instance!

It is important to keep your photographs in files so that you can find them quickly when you need them. I file all of my photos alphabetically by animal. If I start to amass a large number of raccoon photos which include images other than full body shots, I'll file them under more specific headings.

For photos of background elements, I have separate file boxes. Be sure to write the date on the back of each photo so you can find the negatives, which should also be in files. It is also a good idea to write on the back of the photo the subject and where the photo was taken.

You can file pictures cut from magazines and booklets about animals, too. While you wouldn't want to use someone's copyrighted photograph as your main reference source, these photos can give you good information about details of the animal's anatomy.

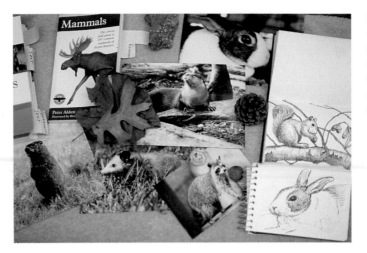

Some kinds of reference materials I use for my paintings: reference photos I've taken, found objects, animal books and sketches from life.

Observing and Sketching Animals From Life

Observation and sketching from life go hand in hand. The more time you spend doing this, the more familiar you will become with each kind of animal. It's a good idea to carry your camera and your sketchbook wherever you go, as you never know when you may happen upon an interesting subject. Sketching animals can be frustrating at times, since they won't pose no matter how well you offer to pay! However, sketching animals from life is also a lot of fun, and by doing so, you'll learn more about the animals than you realize.

Found Objects

Found objects are natural things that add interest to your paintings, such as an acorn, a fallen log, autumn leaves or an ear of corn. You can bring such objects into your studio and incorporate them into your artwork. Set them up so the lighting is the same as the lighting on the animal in your reference photo.

Reference Books

I often refer to reference books. Field guides have a lot of good information, including pictures, descriptions of distinctive traits such as coloring and anatomical characteristics, and information about the animals' habitat. I also have a large collection of animal picture books that I refer to for details. I've bought many of these books at library book sales, where you can often get good books at an extremely low price. Children's animal books are often filled with good pictures, and you can often find a specialized book on a particular animal. Of course, you can also check books out of your local library.

Using Glass Eyes

I have several sets of glass eyes for various species of animals that I ordered through a taxidermy shop. These glass eyes are very realistic, with the correct color and pupil shape for each animal. Sometimes the detail in the eyes doesn't show up in photographs, and these provide me with some valuable information. You can use modeling clay to hold the glass eye, then light it from the correct angle.

Transferring Sketches

To transfer your sketch onto the painting surface, you'll need transfer paper. You can make your own transfer paper following these steps:

1. Take a thin sheet of paper (tracing paper works well), and use a no. 2 pencil to cover one side of the paper with graphite.

2. Lay the tracing paper, pencil-side down, on your painting surface. Position your sketch on top of the transfer paper. Use masking tape to attach the two pieces of paper to the surface.

3. Draw over the lines of your sketch with a mechanical pencil. You can lift up the paper occasionally to see if you are either pressing too hard or not hard enough, and to check which parts of the drawing you've already traced.

This may seem like a lot of work, but you can use this homemade transfer paper over and over again. (One 18" × 24" [46cm × 61cm] piece I made lasted for years!) Do not use commercial carbon paper, as it contains a waxy material that will not erase well.

Suppose your sketch is perfect, except you'd like it to be larger for the size canvas you'll be working on. An easy way to enlarge your drawing to the exact size and choose its placement on the canvas is to use an opaque projector. When you've positioned it the way you want, you can trace your drawing onto the canvas. This will be a little more difficult than you think, as your shadow gets in the way, forcing you to stand off to one side. However, you'll end up with a rough but usable sketch, and it will save you hours of unnecessary work.

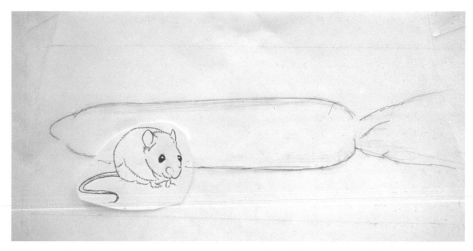

This sketch is ready to be transferred to the painting surface. The mouse sketch was sized using a copier machine. Notice how I have cut the sketch of the mouse out separately so it could be positioned in front of the ear of corn. After trying out several positions I decided on this one, then attached the mouse sketch with a ball of masking tape.

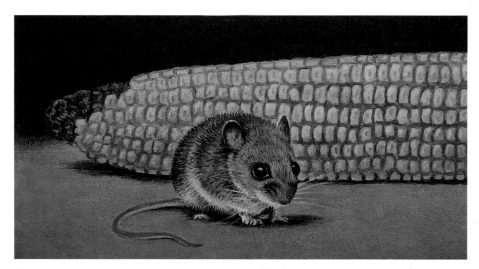

Here is the mouse in the finished painting, *Templeton T. Mouse*.

If you don't have access to an opaque projector, you can also use a copy machine to reduce or enlarge drawings, then you can trace the sketch onto your surface.

Tip

To avoid smudging your drawing with your hand while you are working, place a piece of clean copier paper on the section of the drawing where you are resting your hand.

1

RABBITS AND HARES

Just about everyone is familiar with rabbits, whether it's the cottontail you occasionally see in your backyard, a rabbit kept as a family pet, or rabbits being shown at a county fair or petting zoo. If you live or have traveled in the West, you may also be familiar with the jackrabbit, which is a member of the hare family. Both rabbits and hares have long ears, large eyes, small tails and large hind feet. There are also some important differences. Hares are usually larger than rabbits and have longer ears and hind legs. Hares live in a more open habitat, and escape from danger by running long distances, while rabbits seek safety by running into brush or underground burrows. Hares live alone or in loose groups; rabbits live in very organized family groups. In this chapter, I've included the Eastern cottontail, the black-tailed jackrabbit, and the domestic rabbit, which is descended from the wild European rabbit.

Sprucing Up
Oil on canvas
9" × 12" (23cm × 30cm)
Collection of the artist

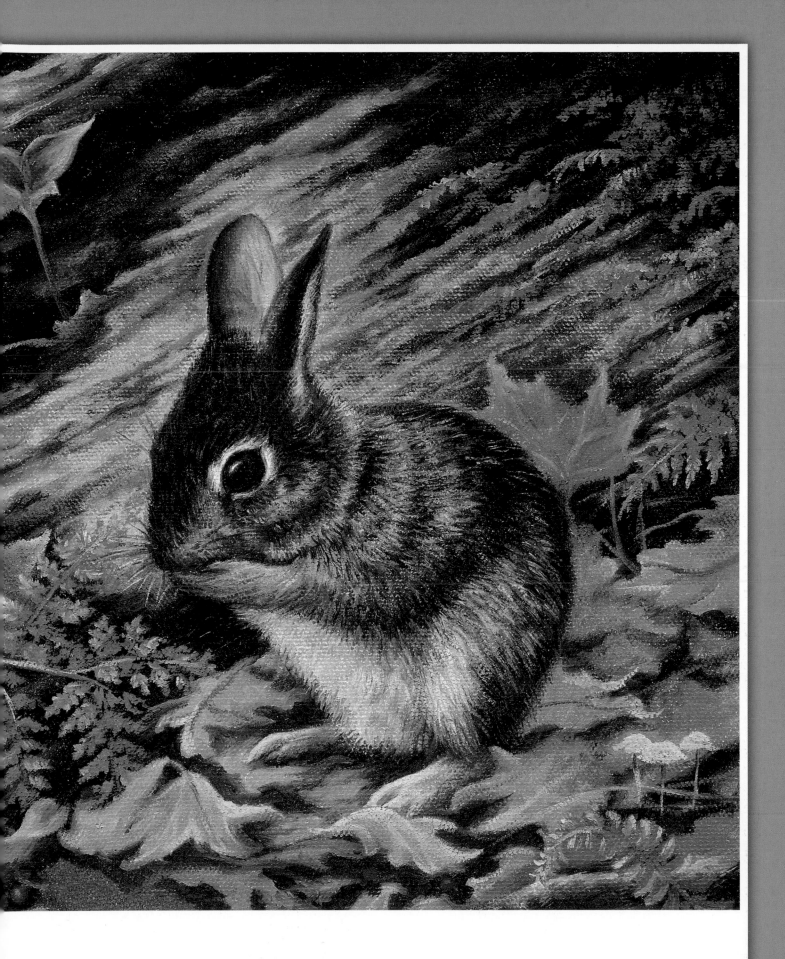

Typical Characteristics

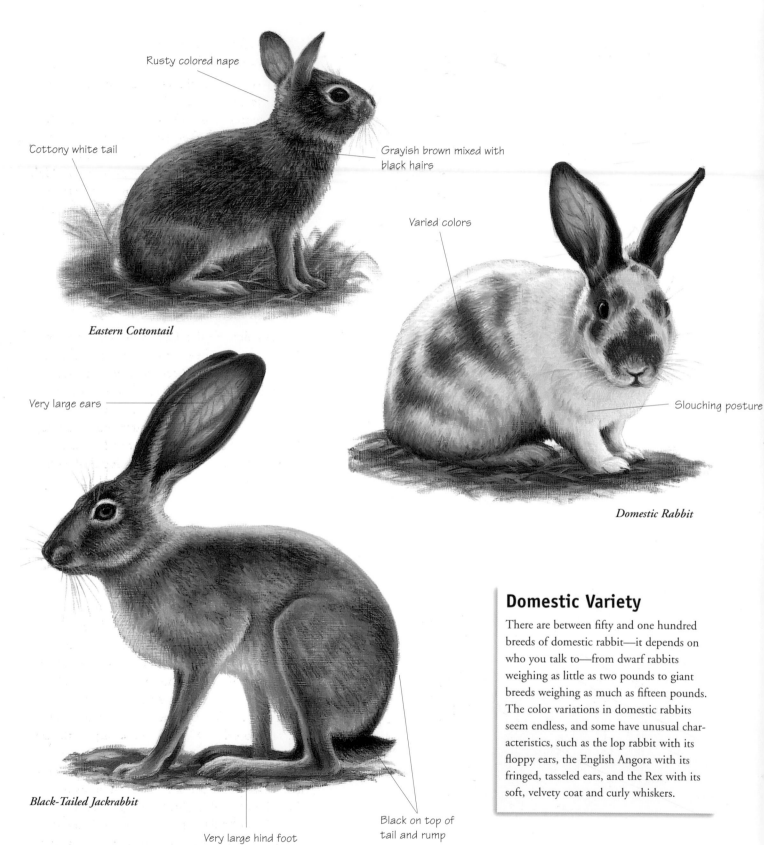

Rusty colored nape

Cottony white tail

Grayish brown mixed with black hairs

Eastern Cottontail

Varied colors

Slouching posture

Domestic Rabbit

Very large ears

Very large hind foot

Black on top of tail and rump

Black-Tailed Jackrabbit

Domestic Variety

There are between fifty and one hundred breeds of domestic rabbit—it depends on who you talk to—from dwarf rabbits weighing as little as two pounds to giant breeds weighing as much as fifteen pounds. The color variations in domestic rabbits seem endless, and some have unusual characteristics, such as the lop rabbit with its floppy ears, the English Angora with its fringed, tasseled ears, and the Rex with its soft, velvety coat and curly whiskers.

Mini-Demonstration

Cottontail Rabbit Ears
OIL ON GESSO-PRIMED MASONITE

MATERIALS

Colors
Burnt Sienna
Burnt Umber
Cadmium Orange
Cadmium Red Light
Cadmium Yellow
 Light
Raw Umber
Titanium White
Ultramarine Blue

Brushes
no. 0, 1 and 3
 rounds
no. 2 filberts

STEP 1: *Establish Form and Darker Values*

Lightly sketch the rabbit's head in pencil. Use Burnt Umber thinned with turpentine and a no. 3 round to paint the darks and basic lines, leaving the white of the surface for the lighter areas. Then, mix Burnt Umber, Burnt Sienna and Ultramarine Blue for the darkest value color. Use a no. 1 round. Use a clean no. 2 filbert to blend and smooth out areas that are too dark or unblended.

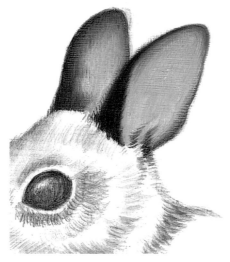

STEP 2: *Paint Middle Values*

Mix Titanium White, Cadmium Red Light and Raw Umber for the pinkish color inside the ear. Apply with a no. 2 filbert. With another no. 2 filbert, blend the dark edges of the ear into the pink color. To paint the fuzzy edge of the ear closest to you and the hair pattern going inside the ear, use the dark value color and a no. 1 round. Use short brushstrokes going in the direction of hair growth.

Tips

 Varying the amount of Liquin you use will enable you to make the shade of color lighter or darker.

 As the paint dries (after several minutes) it becomes easier to blend, but if you wait too long it will be too dry to blend.

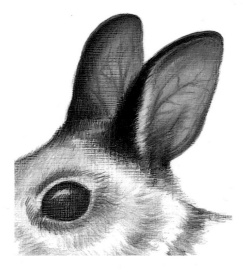

STEP 3: *Add Detail to Ears*

For the veins, mix Cadmium Red Light, Titanium White, Burnt Sienna and Burnt Umber. Use a no. 0 round to paint them over the wet paint inside the ear, making them darker and slightly thicker at the base of the ear. With a clean no. 2 filbert, blend the veins with the background color. Use the vein color mix and the same brush to blend the dark edge of the ear with the pinkish color, and to paint the inside shadows. For the whitish hairs bordering the ear, mix Titanium White with small amounts of Cadmium Yellow Light, Raw Umber and Cadmium Orange. Apply with a no. 1 round using short brushstrokes. When dry, strengthen the highlights and shadows.

Jackrabbit Ears

ACRYLIC ON ILLUSTRATION BOARD

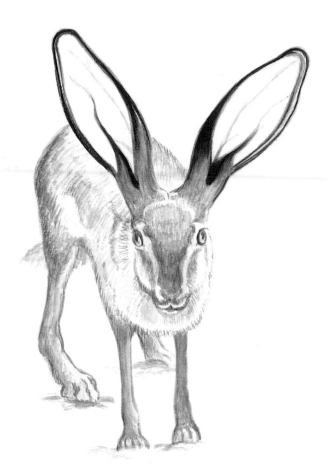

MATERIALS

Colors	Brushes
Burnt Umber	no. 1 and 3
Scarlet Red	rounds
Titanium White	no. 2 and 6 fil-
Ultramarine Blue	berts
Yellow Oxide	

STEP 1: *Establish Form and Basic Light and Dark Values*

Over a light pencil sketch, use Burnt Umber thinned with water and a no. 3 round to establish the basic lights and darks. For the darkest values, mix Scarlet Red, Burnt Umber and a little Ultramarine Blue. Use a no. 1 round with a small amount of water to begin painting the dark parts of the ears.

STEP 2: *Paint Dark Values and Begin Details*

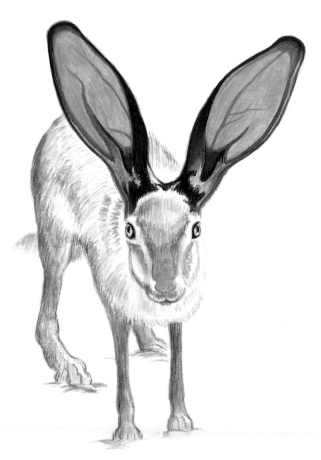

For the medium pinkish color inside the ear fold and around the edges of the ears, mix Scarlet Red, Burnt Umber and Titanium White. With a no. 1 round and enough water to make the paint flow, paint the veins and the darker area inside the ear fold. For the charcoal gray color at the base of the ears, mix Burnt Umber, Ultramarine Blue and Titanium White. Use a no. 1 round to apply, using short brushstrokes. Use the same color to paint a wash over the pinkish color at the edges of the ears to darken them. For the warm color inside the ears, mix Titanium White, Yellow Oxide and Scarlet Red. Apply to the insides of the ears with a no. 6 filbert and enough water to make the paint flow thinly, so that the white surface shows through. Paint right over the veins.

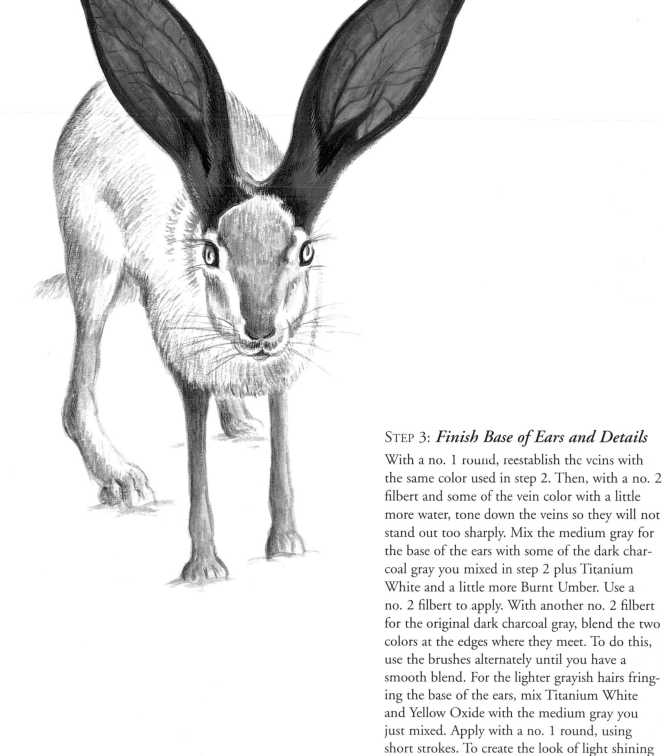

STEP 3: *Finish Base of Ears and Details*

With a no. 1 round, reestablish the veins with the same color used in step 2. Then, with a no. 2 filbert and some of the vein color with a little more water, tone down the veins so they will not stand out too sharply. Mix the medium gray for the base of the ears with some of the dark charcoal gray you mixed in step 2 plus Titanium White and a little more Burnt Umber. Use a no. 2 filbert to apply. With another no. 2 filbert for the original dark charcoal gray, blend the two colors at the edges where they meet. To do this, use the brushes alternately until you have a smooth blend. For the lighter grayish hairs fringing the base of the ears, mix Titanium White and Yellow Oxide with the medium gray you just mixed. Apply with a no. 1 round, using short strokes. To create the look of light shining through the jackrabbit's ears, glaze the ears with Scarlet Red and water, using a no. 6 filbert.

Floppy (Lop) Rabbit Ears
EBONY PENCIL ON ILLUSTRATION BOARD

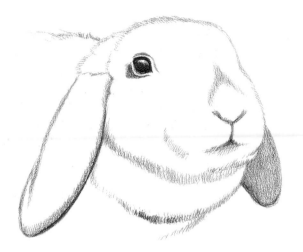

STEP 1: *Establish Form*

Lightly sketch the rabbit's head with a no. 2 pencil. With an Ebony pencil, begin shading in the darker areas of the ears. Use moderate pressure on your pencil at first, working your way up to the darkest darks. This will give you a smoother coverage and make it easier to correct mistakes in the beginning stages. Use a kneaded eraser to lighten or to erase any incorrect lines.

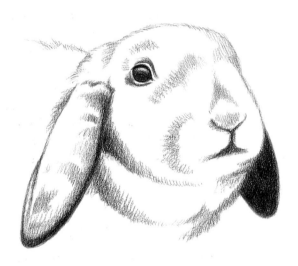

STEP 2: *Build Up Darker Tones*

Begin to darken the shadowed areas, building up the tones gradually rather than all at once. This will give you more even tones. Use pencil strokes that follow the hair growth pattern.

Tip

Keep at least two sharpened pencils ready to use so you won't have to stop and sharpen your pencil too often. Use sandpaper to make the point even sharper, rubbing the pencil point on the sandpaper with a sideways rolling motion. Wipe excess graphite from the point with a paper towel.

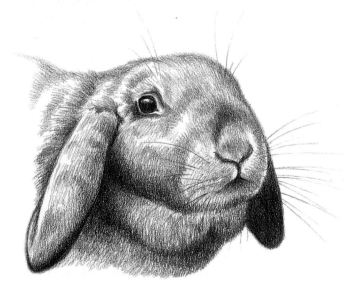

STEP 3: *Add Finishing Details*

Continue adding detail to the fur. Make the ear stand out from the head by sharpening the dark line of the shadowed part of the ear against the lighter fur behind it, and by darkening the fur behind the lighted side of the ear.

Cottontail Rabbit Feet
GOUACHE ON ILLUSTRATION BOARD

Colors
Burnt Sienna
Burnt Umber
Cadmium Yellow
 Deep
Yellow Ochre
Zinc White

Brushes
no. 1, 3 and 5
 rounds

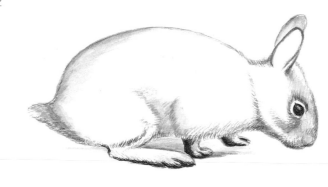

STEP 1: *Establish Form and Paint Basic Lights and Darks*

Over a light pencil sketch, use Burnt Umber thinned with water and a no. 5 round to lightly paint the dark values, leaving the white of the surface for the lighter areas. Using Burnt Umber and a no. 3 round with a small amount of water, paint the dark line of the shadow where the hind foot meets the ground, and the shadowed parts of the front feet.

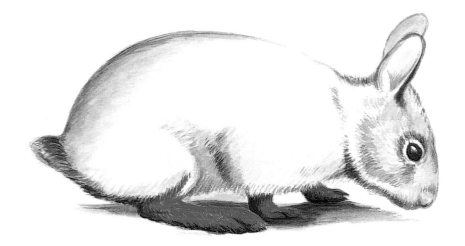

STEP 2: *Paint Middle Value*

For the warm, brownish middle value, mix Zinc White, Yellow Ochre, Cadmium Yellow Deep and Burnt Sienna. Use a no. 3 round to apply, overlapping the edges of the dark areas with short, uneven brushstrokes. With another no. 3 round and Burnt Umber, stroke some of the dark paint up into the middle-value color to create the look of fur.

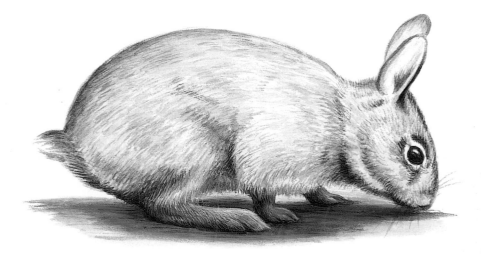

STEP 3: *Add Highlights*

For the lighter value color, mix Zinc White and Yellow Ochre. Apply to the hind foot with a no. 3 round with short, parallel brushstrokes that follow the hair pattern. Overlap the middle-value color, working your way from the top of the foot (where you will use brushstrokes of the lighter color very close together) to the bottom (where more of the middle value shows through). With a separate no. 1 round and the middle-value color, blend up into the lighter color. Complete the front feet using the same technique. Use Zinc White and a no. 1 round to highlight the top edges of the hind foot and the front feet.

Cottontail Rabbit Eyes, Nose and Whiskers
OIL ON GESSO-PRIMED MASONITE

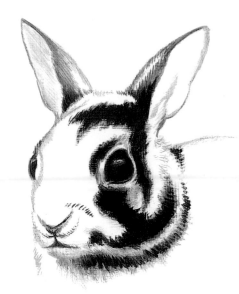

MATERIALS	
Colors	Raw Umber
Burnt Umber	Titanium White
Cadmium	Ultramarine Blue
Orange	
Cadmium Red	**Brushes**
Light	no. 0 and 1
Cadmium Yellow	rounds
Light	no. 2 filberts

STEP 1: *Establish Form and Basic Values*

Sketch the rabbit's head lightly in pencil. Use Burnt Umber thinned with turpentine and a no. 1 round to paint the basic values and shapes. For the darkest value, mix Burnt Umber and Ultramarine Blue and use a no. 1 round.

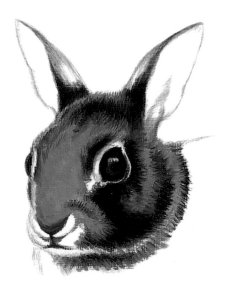

STEP 2: *Add Middle Values*

Use Titanium White, Cadmium Red Light, Cadmium Orange and a little Burnt Umber with a no. 0 round to paint the nose. Then mix a small amount of this color with a little Burnt Umber and Cadmium Red Light to paint the darker lines around the nose and mouth. Use a clean no. 0 round to lightly blend, reestablishing the darks as needed.

Mix Titanium White, Raw Umber and a bit of Cadmium Orange for the fur. Apply with a no. 2 filbert in the direction of fur growth. Blend where the middle and dark values meet with a no. 2 filbert and Burnt Umber. Stroke the dark brown into the middle value to begin creating the look of fur. Next, use a mixture of Burnt Sienna, Cadmium Orange and a touch of Titanium White to paint the iris, using a no. 0 round and a circular stroke. Blend the edges of the iris with another no. 0 round and Burnt Umber. Don't make the eye all one color by overblending.

STEP 3: *Add Highlights and Finish Details*

For the light fur around the eye, muzzle and chin, mix Titanium White with a touch of Cadmium Yellow Light. Use a no. 1 round and small strokes to overlap the darker color and give it the look of fur. For the eye highlight, mix Titanium White with small amounts of Ultramarine Blue and Burnt Umber and apply with a no. 1 round. Use a no. 0 round and Burnt Umber to blend the edges of the highlight.

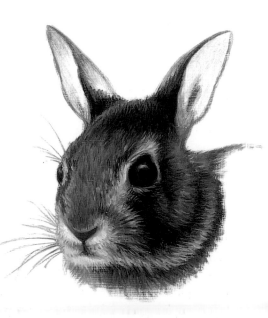

To paint the whiskers, mix Burnt Umber and Titanium White. For the whiskers against the white background, add more Titanium White to create a pale grayish color. Use a no. 1 round to paint them with curving strokes. The base of some of the whiskers should be darker, fading out toward the tip. Make some of the whiskers longer than others. Tone down dark whiskers with a no. 1 round and a small amount of Titanium White.

Jackrabbit Eyes, Nose and Whiskers
GOUACHE ON ILLUSTRATION BOARD

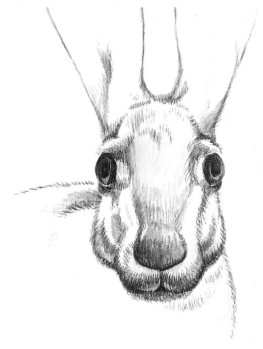

MATERIALS	
Colors	Yellow Ochre
Burnt Sienna	Zinc White
Burnt Umber	
Cadmium Yellow	**Brushes**
Deep	no. 0 and 1
Ultramarine Blue	rounds

STEP 1: *Establish Form and Basic Values*

Sketch the head lightly in pencil. Use Burnt Umber thinned with water and a no. 1 round to paint the forms and values. Use less pigment at first, until you have the lines correct. If you paint a line that is incorrect—either too dark or the wrong angle—use a clean, moistened brush to lighten or erase the line.

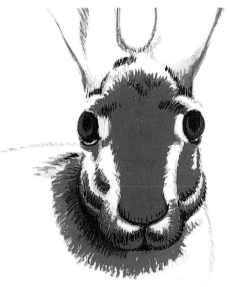

STEP 2: *Paint Dark and Middle Values*

For the darkest fur, mix Burnt Umber, Ultramarine Blue and a bit of Zinc White. Paint with a no. 1 round, following the hair pattern. Dip just the tip of the brush in water before dipping it into the paint. Paint the brownish middle value with a no. 1 round and some water with a mix of Zinc White, Yellow Ochre and small amounts of Burnt Umber and Cadmium Yellow Deep. Overlap the edges where the two values meet with small, parallel strokes. Paint the eye with a mix of Burnt Sienna, Cadmium Yellow Deep and Zinc White and a no. 0 round.

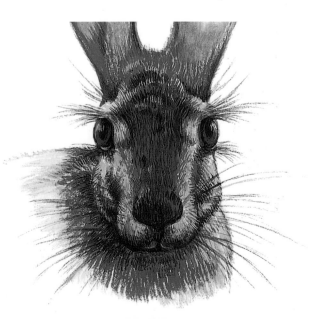

STEP 3: *Add Details and Highlights*

Reestablish the darks that were covered up by the middle value and blend as needed. Use small, parallel brushstrokes to add detail to the broad middle-value areas, such as the front of the face between the eyes and down to the nose. Use light pressure on the brush so the strokes will be thin. Blend the dark and middle values where the edges meet. With a clean, moistened no. 0 round, blend the dark edges of the eye and pupil with the brown eye color.

 Use no. 0 rounds to finish. For the eye highlight, mix Zinc White with a little Ultramarine Blue and paint it following the curve of the eyeball. For the lighter, bluish shadows under the nose, mix Zinc White, Ultramarine Blue and a little Burnt Umber. Blend with the dark value. To paint the eyelashes and whiskers, use some of the dark value color and water. Blot the tip of your brush on a paper towel before applying the paint in light, sweeping strokes.

Dutch Rabbit

OIL ON GESSO-PRIMED MASONITE

MATERIALS

Colors
Burnt Sienna
Burnt Umber
Cadmium Red Light
Payne's Gray
Titanium White
Ultramarine Blue
Yellow Ochre

Brushes
no. 0 and 1 rounds
no. 2 and 4 filberts

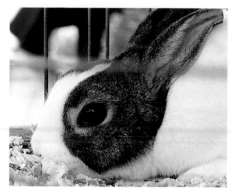
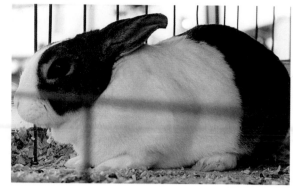

Reference Photos

STEP 1: *Establish Lights, Darks and Basic Form*

Lightly sketch the rabbit with pencil. Use Payne's Gray thinned with turpentine and a no. 1 round to paint the basic lights and darks. Use a no. 2 filbert for the broader areas.

STEP 2: *Paint Darker Values*

For the black fur, mix Burnt Umber and Ultramarine Blue and paint with a no. 4 filbert. Use short brushstrokes in the direction of fur growth. Use a no. 1 round for the smaller details, such as the ears. Paint the eye with some of the black mixture with more Burnt Umber added.

To paint the shadows under the belly, between the toes and under the neck, use Burnt Umber and a no. 1 round. Dip your brush in Liquin only when the paint seems too thick.

STEP 3: *Paint Shadows and Begin Details*

For whatever background you choose, be sure to soften the edges of the dark fur color against it using a no. 2 filbert. Next, mix the bluish shadow color for the white part of the fur with Titanium White, Ultramarine Blue and a small amount of Burnt Sienna. With a no. 4 filbert, paint with brushstrokes that follow the hair growth. For the bluish shadows in the black fur, add a little Burnt Umber to some of the color you just mixed. With a no. 1 round, paint around the eye and begin painting detail in the fur of the ear and other areas.

Tip

When painting fur, use parallel brushstrokes that follow the direction of the hair growth. Be sure to vary your strokes—make some slightly longer and some a little shorter—and vary the direction of the strokes a little. This will make the fur look more natural, and you'll avoid the "blow-dried" look.

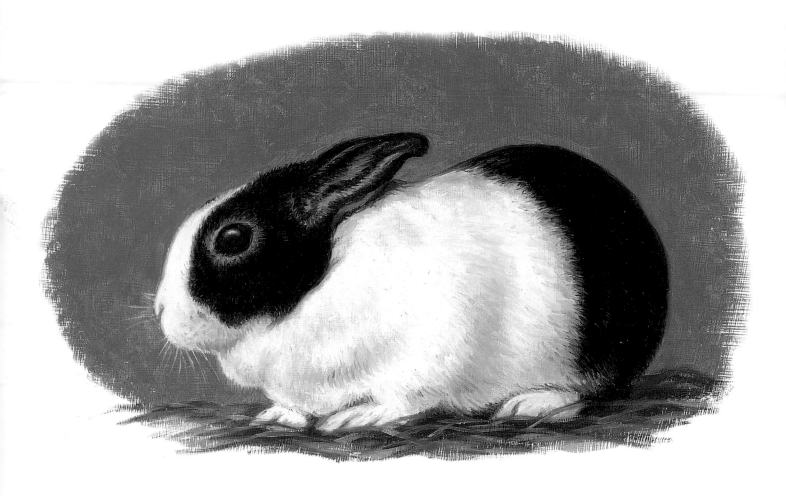

STEP 4: *Paint Lightest Values, Create Fur and Add Details*

Paint over the areas of fur where you left the white of the panel showing with Titanium White and a no. 4 filbert, using brushstrokes that overlap the bluish shadow areas with individual strokes to create a furry look. Follow the rabbit's hair pattern. Use separate no. 1 rounds, one for the bluish shadow color and one for the black fur color, to blend the edges where the white and black fur meet.

For the pinkish nose, mix Cadmium Red Light, Yellow Ochre, Titanium White and a bit of Burnt Umber.

Paint with a no. 0 round. Tone it down with a little Titanium White and a no. 1 round if needed. Paint the whiskers with Titanium White using a no. 0 round. To integrate the rabbit with its surroundings (in this example, straw), reflect a little of the straw color up onto the bluish shadows on the rabbit with a few brushstrokes. (I wiped most of the paint off on a paper towel first so I wouldn't overdo it).

Cottontail Rabbit
ACRYLIC ON ILLUSTRATION BOARD

MATERIALS

Colors	Brushes
Burnt Sienna	no. 1 and 3
Burnt Umber	rounds
Payne's Gray	no. 2, 4 and 6
Raw Sienna	filberts
Raw Umber	
Scarlet Red	
Titanium White	
Ultramarine Blue	

Reference Photo

STEP 1: *Establish Form and Dark Values*

Over a light sketch, use Payne's Gray thinned with water and a no. 1 round to paint the basic darks and lights. Use a no. 6 filbert for the broader areas. For the dark color of the rabbit's coat and eye, mix Burnt Umber and Ultramarine Blue. Paint the eye with a no. 1 round, leaving a white space for the highlight. (If you paint over the highlight by mistake, you can always add it later.)

Use a no. 1 round (for details) and a no. 4 filbert (for the broader areas) to begin painting the darkest shadowed areas around the neck, haunch, under the eye, etc. Use brushstrokes that follow the way the hair grows. It will take more than one layer of paint to cover the dark areas. As soon as one layer is dry, you can darken it by adding another layer.

STEP 2: *Paint Middle Value*

For the brownish middle-value color, mix Raw Sienna, Burnt Sienna and Titanium White. Apply with a no. 4 filbert. First, dip the tip of your brush in water, then in the paint. Paint right up to the dark areas, overlapping with short, uneven brushstrokes at the edges where the two colors meet.

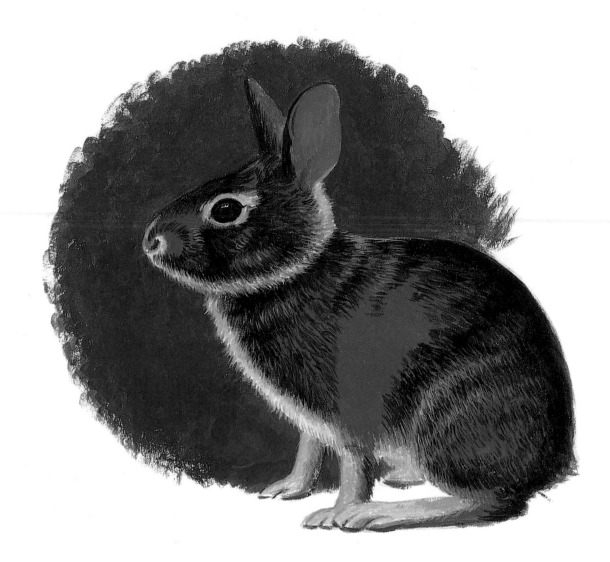

STEP 3: *Begin Fur Details*

With the dark fur color and a no. 1 round, begin painting fur detail over the middle-value color, following the fur pattern. Mix a lighter fur color using Titanium White and Raw Umber. With a no. 3 round, begin painting the chest fur against your background, and begin adding lighter hairs around the eye, head, shoulders and haunches. Use the same color and brush to paint the lighter parts of the legs and feet. For the pink color inside the ear, mix Scarlet Red, Burnt Umber, Titanium White and a little Ultramarine Blue. Apply with a no. 2 filbert.

Tips

• Make fur more realistic by painting some tufts of fur—triangular in shape with the top end open. Some artists make the mistake of painting fur as if it were just a series of thin lines all going in the same direction.

• Tone down any areas of light-colored fur that look too bright or stand out too much with a thin glaze of Burnt Umber and water.

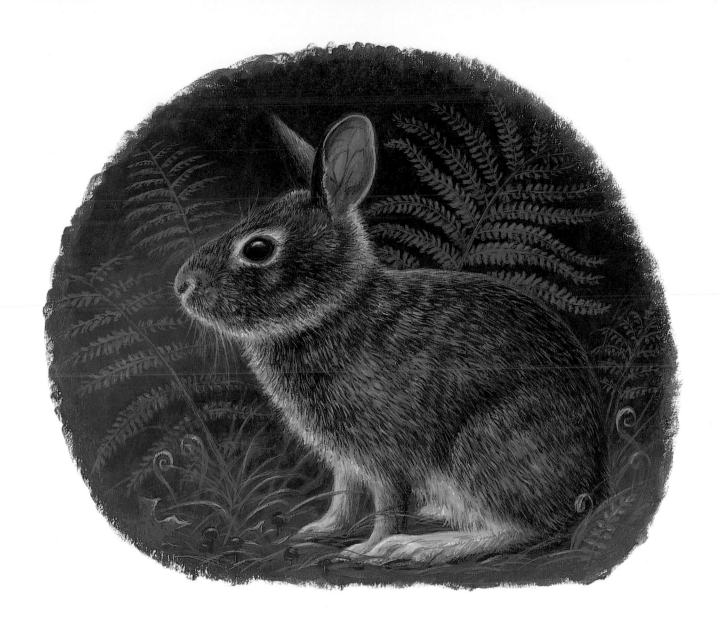

STEP 4: *Finish Details*

Add more dark hairs with a no. 1 round and the dark value you mixed in step two. Vary your brushstrokes so they aren't all in the same direction. Use a no. 1 round and the light fur color to continue the fur. Integrate the areas where the light and dark fur meet by stroking one color into the other at the edges, using separate brushes for each.

Paint a highlight on the edge of the closest ear with a no. 1 round and some of the light fur mixture. For areas where this mixture would be too light, mix a little of the light and middle-value fur colors together. Use short strokes on the head and slightly longer strokes on the body. Mix a little Titanium White with Ultramarine Blue and paint the eye highlight with a no. 1 round, then blend the edges.

Use a no. 1 round and a mixture of Scarlet Red, Burnt Umber and Titanium White to paint the veins inside the ear. Use some of the pinkish ear color mixture from step 3 (thinned with water) and a no. 1 round to tone them down. Paint the shadows inside the ear with a mixture of the pinkish ear color and Burnt Umber, then blend.

With a no. 1 round, paint the whiskers with some of the light fur color and enough water so the paint flows. Use a no. 1 round and some of your background color to tone them down as needed.

2

SQUIRRELS

The squirrel family includes chipmunks, ground squirrels, tree squirrels and prairie dogs. In this chapter, I've included Eastern chipmunks (also called ground squirrels), Columbian ground squirrels, blacktail prairie dogs, Eastern gray squirrels and red squirrels.

It is important for the artist to know that within a species, individual animals may vary greatly in color. They may also vary in color depending on the time of year. For example, gray squirrels are usually gray to brownish gray with white underparts, but sometimes they are brownish underneath. In summer they may be more tawny colored than gray, and there are some "gray" squirrels that are actually all black or all white! They are all individuals, which only makes them more interesting subjects for your artwork.

Cabin Squatter
Oil on canvas
12" × 14" (30cm × 36cm)
Private collection

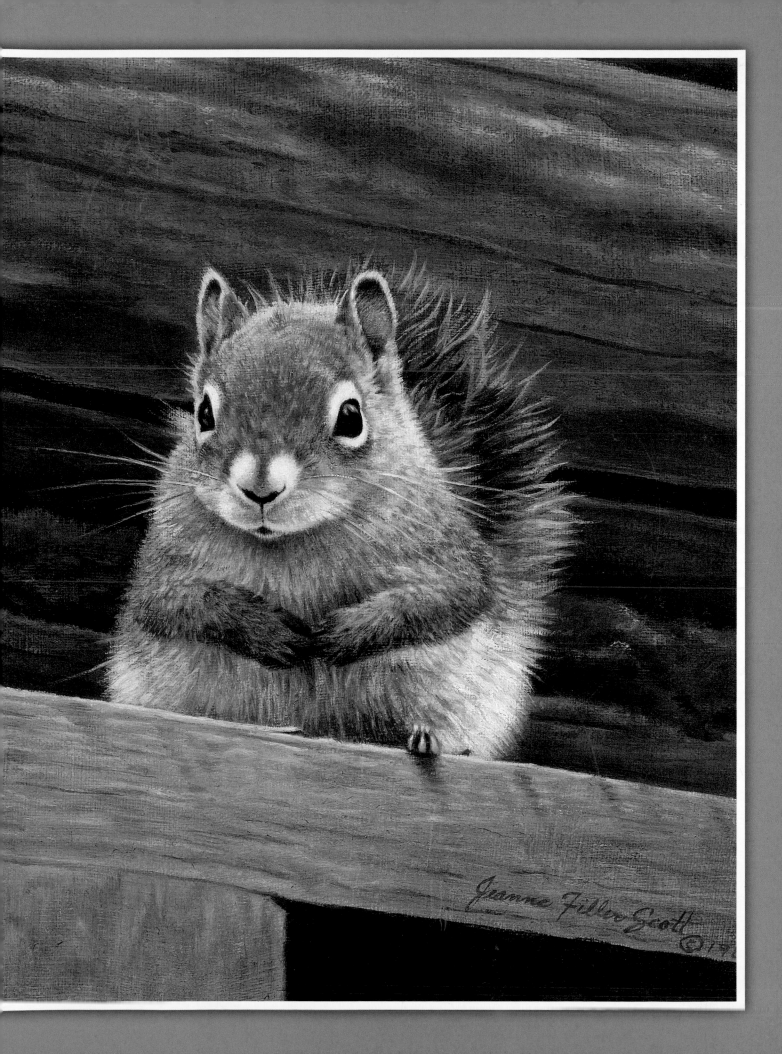

Jeanne Filler Scott
© 1?

Typical Characteristics

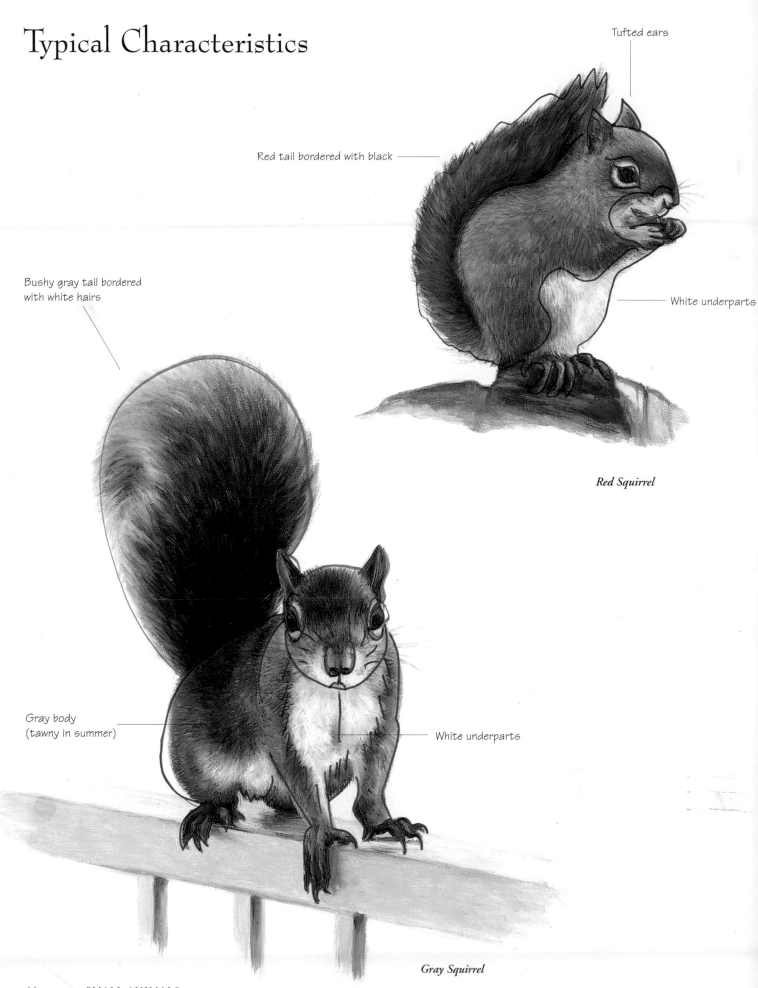

Tufted ears

Red tail bordered with black

White underparts

Red Squirrel

Bushy gray tail bordered with white hairs

Gray body (tawny in summer)

White underparts

Gray Squirrel

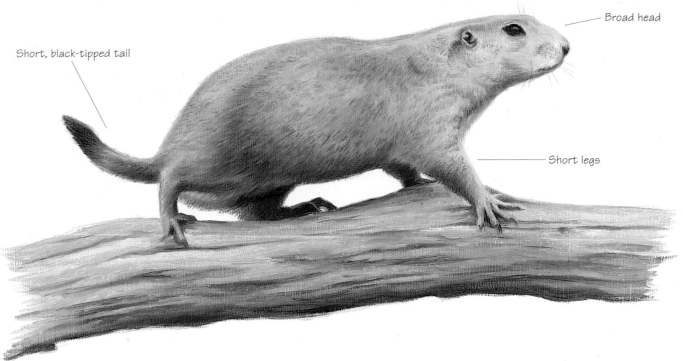

Short, black-tipped tail

Broad head

Short legs

Blacktail Prairie Dog

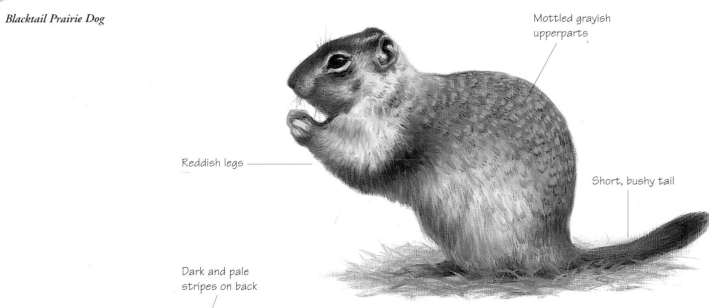

Mottled grayish
upperparts

Reddish legs

Short, bushy tail

Columbian Ground Squirrel

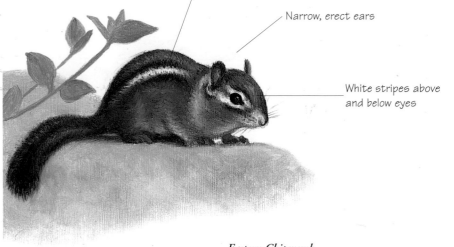

Dark and pale
stripes on back

Narrow, erect ears

White stripes above
and below eyes

Eastern Chipmunk

Gray Squirrel Tail
OIL ON CANVAS

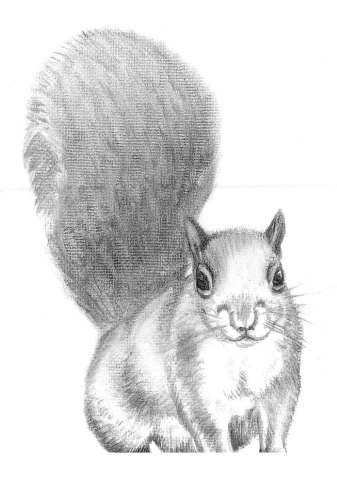

MATERIALS	
Colors	**Brushes**
Burnt Sienna	no. 3 round
Burnt Umber	no. 2 and 6
Payne's Gray	filberts
Raw Sienna	
Titanium White	
Ultramarine Blue	

STEP 1: *Establish Form*

Draw the squirrel lightly in pencil, then use Payne's Gray thinned with turpentine to do an underpainting showing the basic form and the dark and light areas. Use a no. 2 filbert for the broader parts, such as the tail and body, and a no. 3 round for smaller details such as the eyes, ears and feet.

STEP 2: *Paint Darker Values*

Mix the dark value for the squirrel's tail using Burnt Umber, Burnt Sienna, and a small amount of Ultramarine Blue. Begin painting the dark part of the tail with fairly short, sweeping strokes in the direction the hair grows. Use a no. 3 round around the body contour, and a no. 6 filbert for the rest of the tail. Feather the edges as you paint out to the sides and top of the tail by gradually putting lighter pressure on the brush as you move toward the edges.

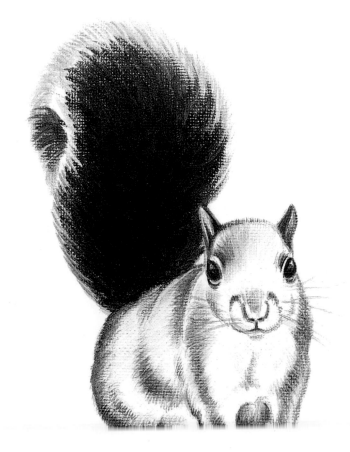

Step 3: *Add Middle Values*

Mix the middle-value color using Burnt Sienna, Burnt Umber and a small amount of Titanium White. Use a no. 6 filbert to paint the larger areas around the edge of the dark part of the tail, and a no. 2 filbert for the hair under the curve of the tail. Use a separate, clean no. 6 filbert to blend the dark and middle values with back-and-forth strokes. Don't overblend; stroke one color into the other to make it look like tufts of hair.

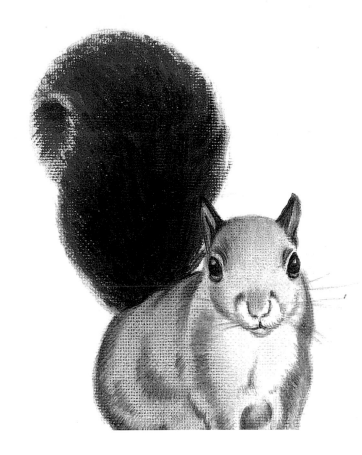

Step 4: *Add Lightest Values*

To mix the lighter value, use Titanium White with small amounts of Burnt Sienna and Ultramarine Blue. With a no. 2 filbert, paint the broader areas and blend the outer edge of the tail. With the same no. 2 filberts used to paint the middle and light values, blend and feather the edges where those values meet. Alternate between the two brushes, creating the illusion of hair. Add some lighter detail to the darker areas with short, sweeping strokes.

When dry, add some lighter highlights by mixing Titanium White and small amounts of Burnt Umber and Raw Sienna. Use a no. 3 round. Then add a touch more Burnt Umber to some of the highlight mixture and blend the edges of the highlights. When painting a squirrel against a dark background, the tail will stand out well; but to make the tail stand out against a light background, you'll need to slightly darken the edge of the tail where it meets the background.

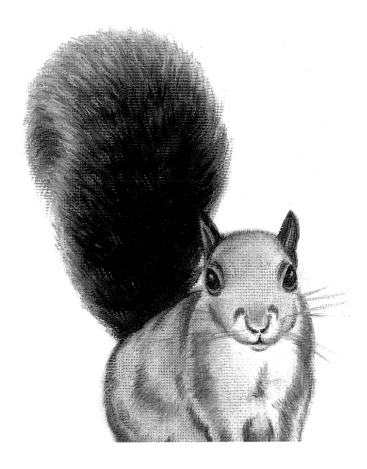

Red Squirrel Tail
ACRYLIC ON GESSO-PRIMED MASONITE

Colors		Brushes		MATERIALS
Acra Red	Cadmium Yellow Light	no. 1 and 3 rounds		
Burnt Sienna	Payne's Gray			
Burnt Umber	Titanium White			
Cadmium Orange	Ultramarine Blue			

Drybrushing

Drybrush is a technique using a small amount of paint and very little medium (water, Liquin, etc.) on the brush, so that when you paint, a "broken" effect is achieved—some of the underlying color shows through. This works well for creating soft lines that integrate with the color underneath.

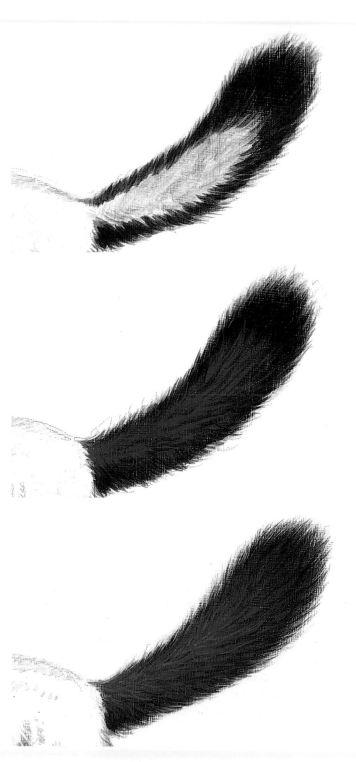

STEP 1: *Establish Form and Darker Values*

Over a light pencil drawing, use Payne's Gray thinned with water and a no. 3 round to indicate the lights and darks and the basic shapes. Mix Burnt Umber, Burnt Sienna and a small amount of Ultramarine Blue for the blackish tail fringe. Paint with a no. 3 round in the direction that the hair grows, feathering the edges. Use just enough water to make the paint flow.

STEP 2: *Add Middle Values*

For the reddish middle value, mix Burnt Sienna, Cadmium Orange, Acra Red and a small amount of Titanium White. Use a no. 3 round and the same kind of brushstrokes you used in the first step, overlapping the edges of the dark areas with feathered strokes of red. Using a separate no. 3 round, stroke the dark paint mixture into the reddish areas. Alternate between the two colors until you have a natural look. (You'll refine the tail more in step 3.)

STEP 3: *Add Lightest Values and Refine Tail*

Continue to blend between the two hair colors. Overlap some of the dark strokes you put in the red area with a lightly applied stroke of the red color to tone down and integrate the dark hairs. Mix the lightest value with some of the reddish middle value plus Titanium White, Cadmium Yellow Light and a little more Acra Red. Using a no. 1 round, add some light hairs on top of the reddish hairs. Blend them into the tail a little using the reddish color with a different no. 1 round and light, feathery strokes. Blend the dark hairs into the tail using another brush. To soften the tail at the edges, use a no. 1 round to drybrush with the dark value.

Lightly stroke some of the background color (white, in this case) into the tail to make it less uniform. Stroke the edges of the white with some of the dark value and reddish value mixed together to soften the sharpness of the white.

Ground Squirrel Tail

OIL ON CANVAS

MATERIALS

Colors	Titanium White
Burnt Sienna	Ultramarine Blue
Burnt Umber	
Cadmium	**Brushes**
Orange	no. 0 and 3
Cadmium Yellow	rounds
Light	

STEP 1: *Sketch Form and Paint Dark Values*

Over a light pencil sketch, use Burnt Umber thinned with turpentine and a no. 3 round to paint the basic lines and values. Blot your brush occasionally on a paper towel to control the flow of the paint. Mix the darkest value using Burnt Umber, Burnt Sienna and Ultramarine Blue. Use a no. 3 round to paint the darks, stroking in the direction the hair grows.

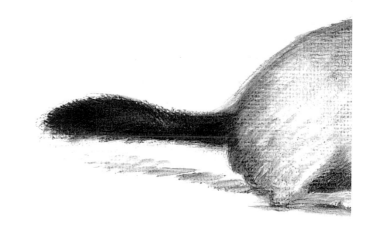

STEP 2: *Paint Middle Values*

Mix the middle-value color with Burnt Sienna, Cadmium Orange and Titanium White. With a no. 3 round, paint the middle section of the tail. Using a separate no. 3 round for the dark value, blend this color with the lighter color. Use short strokes in the direction the tail hairs grow. Alternate between the two brushes with the two colors until it looks natural but not overworked.

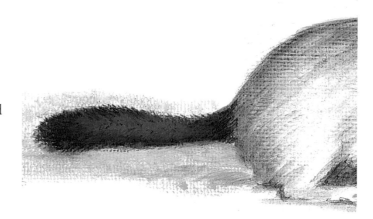

STEP 3: *Add Highlights*

When the painting is dry to the touch, paint the buff tail fringe color with a no. 0 round. Use some of the middle-value color from step 2, adding some Titanium White and a bit of Cadmium Yellow Light. Blend the edges with a separate no. 0 round and some of the dark-value color from step 1. Carefully blend the edge of the tail with the background color. Add a few lighter hairs in the main body of the tail using some of the buff color and a no. 0 round.

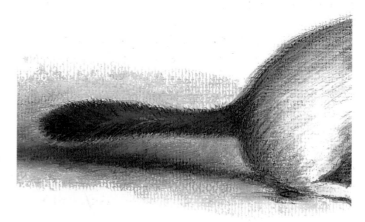

Gray Squirrel Eyes and Ears

ACRYLIC ON GESSO-PRIMED MASONITE

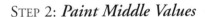

MATERIALS

Colors	Brushes
Burnt Umber	no. 0 and 3
Raw Sienna	rounds
Scarlet Red	
Titanium White	
Ultramarine Blue	
Yellow Oxide	

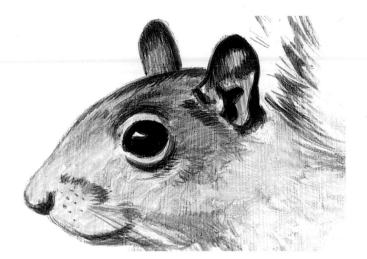

STEP 1: *Paint Darkest Values*

Over a light pencil sketch, paint the basic lines of the squirrel's head with Burnt Umber thinned with water. Use a no. 3 round for broader areas and a no. 0 round for smaller details. Mix the dark values with Burnt Umber and Ultramarine Blue. Paint the darks with a no. 0 round, thinning the paint with water. Use less water for the darker areas, such as the eye and the inside and outer edge of the ear. Leave the highlight of the eye white. Paint short, hatch-line strokes in the direction of fur growth.

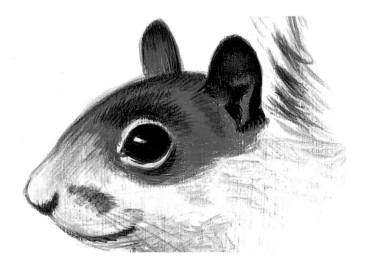

STEP 2: *Paint Middle Values*

For the gray color, mix Titanium White, Burnt Umber and Ultramarine Blue. Paint with a no. 3 round and a small amount of water. Use some of the dark-value color from step 1 and a no. 0 round to paint small strokes of hair around the squirrel's eye. For the pinkish ear, use a no. 0 round and a mixture of Titanium White, Scarlet Red and Burnt Umber. Blend the pink into the dark color using short strokes that overlap the edges of the two colors.

STEP 3: *Paint Highlights and Finishing Touches*

Mix Titanium White, Raw Sienna and Yellow Oxide for the lighter lines around the squirrel's eye. Paint with a no. 0 round, blending this color into the surrounding fur. For the dark brown at the corner of the eye, mix a bit more Raw Sienna and Burnt Umber to the mixture and use a no. 0 round. Blend around the dark edge to soften the line.

For the fur highlights, mix Titanium White with the gray mixture from step 2. Use a no. 3 round to paint with small strokes on top of the head, around the ear and underneath the eye. For the eye highlight, use a very small amount of Titanium White mixed with a little Ultramarine Blue and a no. 0 round.

Gray Squirrel Nose and Whiskers

GOUACHE ON ILLUSTRATION BOARD

MATERIALS

Colors	Yellow Ochre
Burnt Sienna	Zinc White
Burnt Umber	
Cadmium Red	**Brushes**
Pale	no. 0, 1 and 3
Lamp Black	rounds

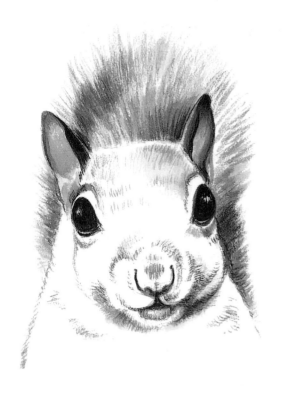

STEP 1: *Paint Darkest Values*

Lightly sketch the squirrel's head in pencil. Press a kneaded eraser on the pencil lines to lighten them so they won't show through when you paint. Using Lamp Black and a no. 3 round dipped in water, paint the darkest values.

STEP 2: *Apply Color Glazes*

With a no. 3 round, glaze the squirrel's nose and mouth with a wash of Burnt Sienna. When dry, follow with a wash of Yellow Ochre. Make your washes light—it is easier to add color than subtract it. Keep doing these thin glazes until you have built up a good rich color. With a no. 1 round, paint thin strokes of Burnt Umber over the Lamp Black in the darker areas of fur. Keep a clean, wet brush (not sopping) to lighten or blend while the paint is still wet. For the pink color of the squirrel's lower lip, use a wash of Cadmium Red Pale followed by a wash of Burnt Sienna, letting the washes dry between applications.

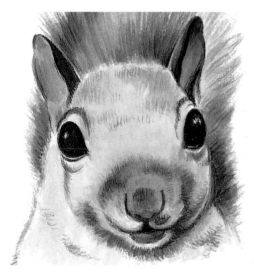

STEP 3: *Strengthen Darks and Refine Fur*

With a mixture of Lamp Black and Burnt Umber and a no. 0 round, strengthen the dark areas, following the hair pattern. Use Zinc White and a no. 0 round to paint the fur under the chin and around the muzzle. Overlap the edges of the dark areas with small strokes of white to create the look of fur. For higher up on the muzzle, mix Yellow Ochre and Zinc White. Use a wet brush (not too wet) to selectively soften areas where the paint has dried. Paint the whiskers with Lamp Black thinned with water and a no. 0 round, using light, sweeping strokes.

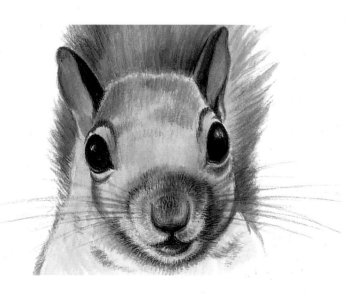

Gray Squirrel
OIL ON GESSO-PRIMED MASONITE

Colors	Raw Sienna
Burnt Umber	Titanium White
Burnt Sienna	Ultramarine Blue
Cadmium Orange	
Cadmium Red	**Brushes**
Light	no. 0, 1, 3 and 5
Cadmium Yellow	rounds
Light	no. 2 filbert
Payne's Gray	

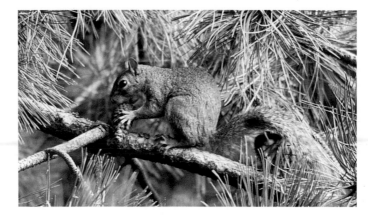

Reference Photo

STEP 1: *Establish Lights, Darks and Basic Form*

Lightly sketch the squirrel in pencil. Use a kneaded eraser to lighten the pencil lines. With Payne's Gray thinned with turpentine and a no. 5 round (for the broader areas) and a no. 1 round (for details), paint the basic lines and values.

STEP 2: *Paint Darker Values*

For the darker values, mix Burnt Umber, Burnt Sienna and a small amount of Ultramarine Blue. Paint the darks with a no. 5 round. With a clean no. 2 filbert, soften the line at the edge of the squirrel's back where it meets your background.

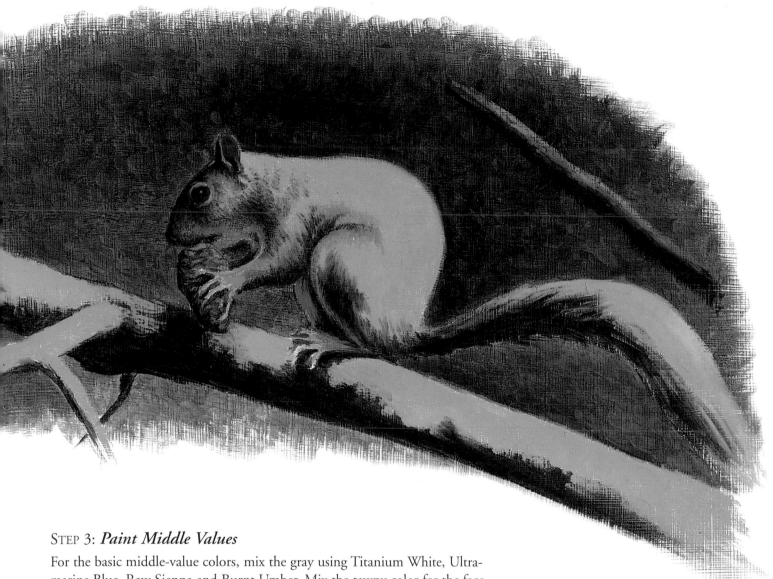

STEP 3: *Paint Middle Values*

For the basic middle-value colors, mix the gray using Titanium White, Ultramarine Blue, Raw Sienna and Burnt Umber. Mix the tawny color for the face, feet and haunches with Titanium White, Raw Sienna, Cadmium Orange and Burnt Sienna. Use no. 3 rounds to paint these colors. Be sure to use brushstrokes that follow the way the hair grows.

For the pinkish inside of the ear, mix Cadmium Red Light, Titanium White and Burnt Umber. Use a no. 1 round. With a separate no. 1 round, get a little Burnt Umber on your brush and paint the dark area inside the ear, blending up into the pinkish color. Take the brush with the pinkish color and blend into the Burnt Umber, too, until you have a good blend between the two colors. Allow the painting to dry overnight.

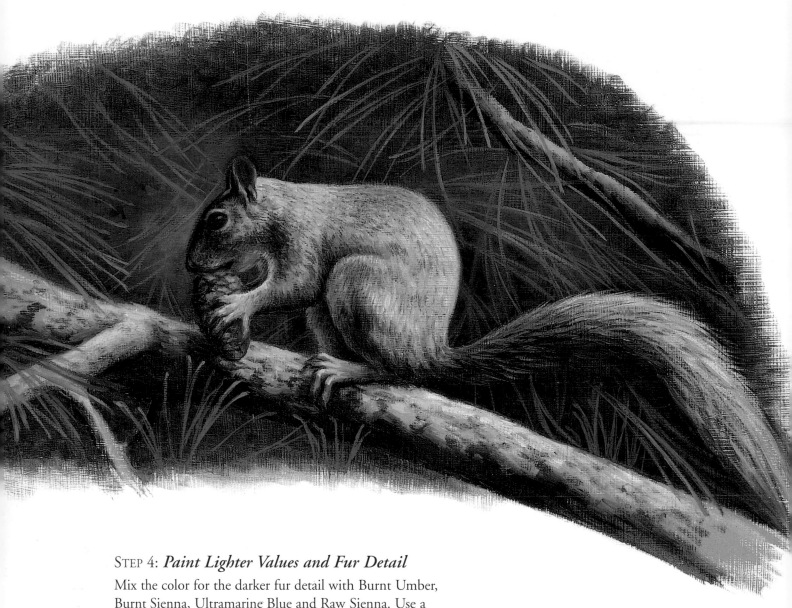

STEP 4: *Paint Lighter Values and Fur Detail*

Mix the color for the darker fur detail with Burnt Umber, Burnt Sienna, Ultramarine Blue and Raw Sienna. Use a no. 0 round to paint some hair texture. Blend with a no. 3 round and some of the gray mixture or tawny mixture from step 3. Blend just enough so that the fur looks natural.

For the highlights, mix Titanium White, a little Raw Sienna and a touch of Cadmium Yellow Light for warmth. Use a no. 0 round to paint small dabs, allowing the paint to be a little thicker in these areas. This will make the squirrel stand out against your background.

Red Squirrel
ACRYLIC ON GESSO-PRIMED MASONITE

MATERIALS	
Colors	Ultramarine Blue
Acra Red	Yellow Ochre
Burnt Umber	
Burnt Sienna	**Brushes**
Cadmium Orange	no. 0, 1 and 3
Raw Sienna	rounds
Titanium White	

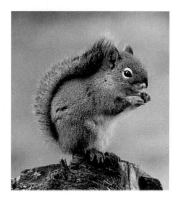

Reference Photo

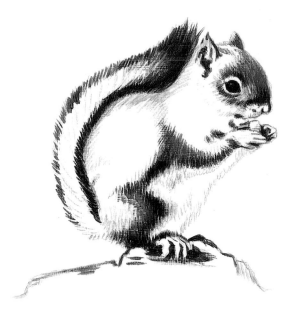

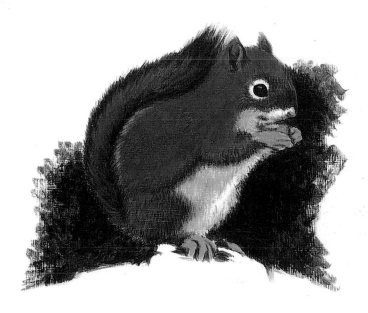

STEP 1: *Paint Dark Values*

Lightly sketch the squirrel in pencil. Paint the basic form of the squirrel with a no. 3 round and Burnt Umber thinned with water. Mix Burnt Umber, a smaller amount of Burnt Sienna and a little Ultramarine Blue for the dark value. Paint these darks with a no. 3 round. Use water to thin your paint to the right consistency. Use brushstrokes that follow the way the hair grows.

Mix Titanium White, Burnt Sienna, Acra Red and Cadmium Orange for the base color of the squirrel. Begin to paint this using a no. 3 round.

STEP 2: *Paint Basic Colors*

Continue painting the reddish base color of the squirrel's body. Dip just the tip of your brush in the water, then in the paint mixture to get the correct amount of water and paint on your brush. When this is dry, add a second coat to completely cover the surface.

Mix Burnt Umber, Burnt Sienna and a small amount of Ultramarine Blue. Begin overlapping the edges of the shadowed areas into the reddish base color. Use short strokes with a no. 3 round. Mix the bluish shadow color for the white underbelly with Titanium White, Ultramarine Blue and a touch of Burnt Sienna for warmth. Paint with a no. 3 round, overlapping the edges of the adjacent color with uneven strokes.

Mix the basic color for the paws and feet with Titanium White, Cadmium Orange and Raw Sienna, and paint with a no. 1 round. Use the same color to begin adding the fur highlights with a no. 3 round along the back line where it meets the tail.

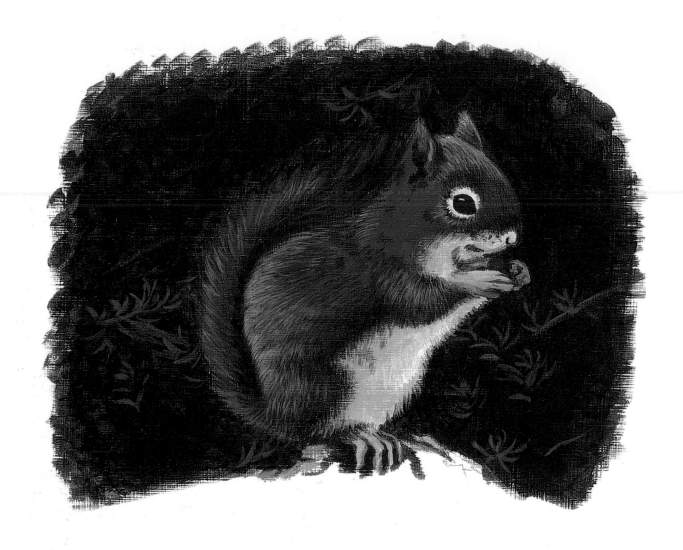

Step 3: *Add Fur Detail*

Continue adding detail to the fur. Use just enough water so the paint flows. Add dark hair patterns with the color you mixed in step 1, followed by the lighter value you mixed in step 2, using no. 1 rounds. Paint with small overlapping strokes. For detail in the bluish shadow areas, dip a no. 1 round into the bluish mixture from step 2, then into some Burnt Umber, and mix on the palette. Apply with small strokes, and overlap the edges with strokes of the bluish mixture.

For highlights in the fur, use some of the color mixture from step 2 that you mixed for the paws and feet. Begin to paint these highlights with a no. 1 round, including the edge of the tail where it meets your background.

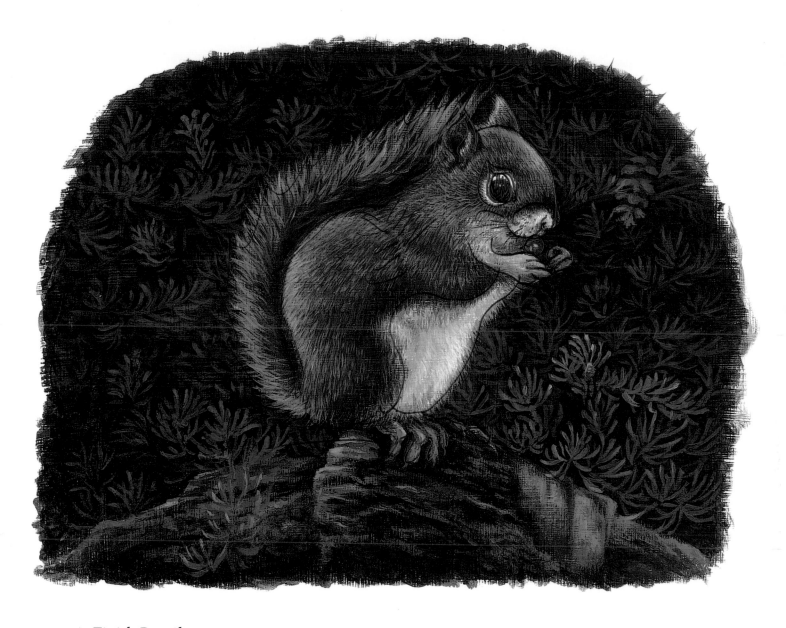

STEP 4: *Finish Details*

Keep overlapping the three basic fur colors alternately, using the reddish value to tone down and soften brushstrokes that appear too sharp. Use Titanium White with a touch of Yellow Ochre to soften and blend the white lines around the eye. With two brushes—a no. 1 round for Titanium White and another no. 1 round for the bluish shadow color—add highlights to the underbelly, then blend the edges with the bluish color.

Use your background color to paint around the toes to refine the shape of the feet and paws. Use the paw and foot color mixture to redefine the shape. Using a no. 1 round, glaze the feet with a thin wash of Burnt Umber. Then, using a no. 1 round and some of the foot color mixed with

Titanium White, paint highlights on the toes. You don't need to glaze the paws with a darker color since the paws are not in shadow. Highlight the paws in the same way as the feet.

Paint the whiskers with a no. 0 round and a very small amount of Burnt Umber thinned with water. Blot your brush lightly on a paper towel before applying the paint. Be careful not to make the whiskers too dark. Paint the eye highlight with a no. 0 round and a small amount of Titanium White mixed with a touch of Ultramarine Blue. Use the dark eye color to refine the shape, and redefine the highlight with the highlight color.

Chipmunk
GOUACHE ON ILLUSTRATION BOARD

MATERIALS

Colors	Brushes
Burnt Sienna	no. 0, 1 and 3
Burnt Umber	rounds
Lamp Black	
Yellow Ochre	
Zinc White	

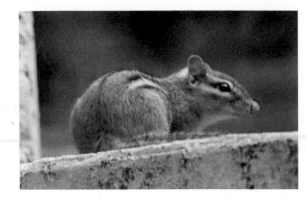

Reference Photo

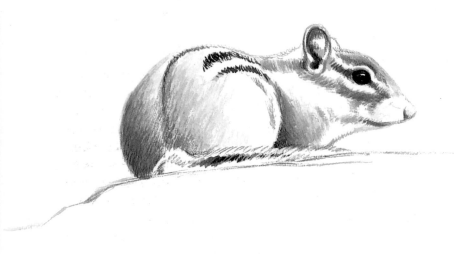

STEP 1: *Establish Form*

Draw the chipmunk lightly in pencil. Begin painting a light wash of Burnt Sienna with a no. 3 round over the chipmunk's body. With a no. 3 round and Lamp Black thinned with water, lightly paint the basic values. For small details such as the eye, use a no. 1 round. If you need to correct the shape of the eye after you have painted it, use some Zinc White and a no. 0 round. (Dip the tip of the brush in water before you dip it in the paint.) You can paint this opaque white over the black.

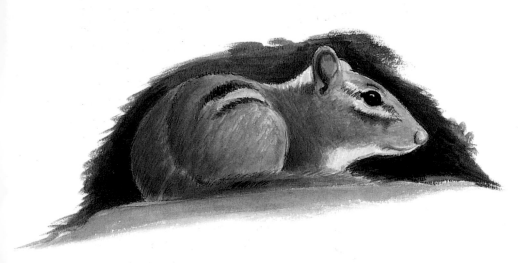

STEP 2: *Apply Washes of Color*

Continue to apply washes of Burnt Sienna with a no. 3 round, allowing the washes to dry between applications.

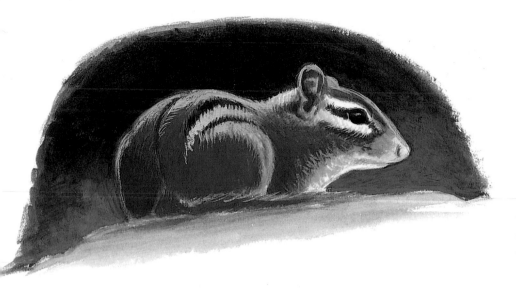

STEP 3: *Apply Richer Colors and Begin Highlights*

Mix Burnt Sienna with a little Burnt Umber and use a no. 3 round to paint a darker, richer color on the chipmunk. Use brushstrokes that follow the hair patterns. Darken the stripes on the back and above and below the eye with a mixture of Burnt Umber and Lamp Black. Begin to paint some highlights on the fur with a mixture of Zinc White and Yellow Ochre, using a no. 1 round.

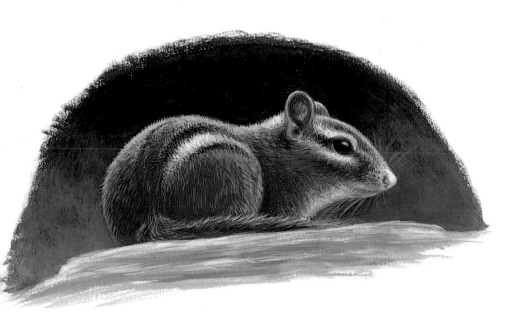

STEP 4: *Add More Fur Detail*

Use the three fur colors you already mixed for step 3 to add more detail to the fur, using separate no. 0 rounds. Overlap the edges of the lighter areas of fur with small individual strokes of the darker color, using a crosshatching technique. Blend the black stripes in the fur into the reddish body color with the same method.

Add both darker and lighter hairs in the larger body areas. For the highlights behind the ear, at the tip of the nose and the white stripe along the back, use pure Zinc White with a very small amount of water and a no. 0 round, dabbing the white on a little thicker than the surrounding paint to make these areas "pop." If some of the hair detail looks too sharp, use a no. 0 round with a light wash of Burnt Sienna to tone it down.

Paint the whiskers with a no. 0 round and the Yellow Ochre–Zinc White mixture. Thin the paint to the consistency of ink. Blot the brush on a paper towel before painting the whiskers with sweeping strokes.

Prairie Dog Eyes
OIL ON GESSO-PRIMED MASONITE

MATERIALS

Colors	Brushes
Burnt Sienna	no. 1 and 3
Burnt Umber	rounds
Cadmium Yellow	no. 6 filbert
Light	
Raw Sienna	
Titanium White	
Ultramarine Blue	

STEP 1: *Establish Form*

Draw the eye lightly in pencil. With a no. 3 round and
Burnt Umber thinned with turpentine, paint in the shape
and dark area of the eye.

STEP 2: *Paint Basic Eye Color*

Mix the eye color with Burnt Umber and Ultramarine
Blue. Use your no. 3 round to paint the eye, leaving a
white space for the highlight. Using a no. 6 filbert, paint
the fur color around the eye with a mixture of Titanium
White, Burnt Sienna and Raw Sienna. For the shadows
above and below the eye, mix Raw Sienna, Burnt Sienna
Titanium White and Ultramarine Blue; use a no. 1 round.

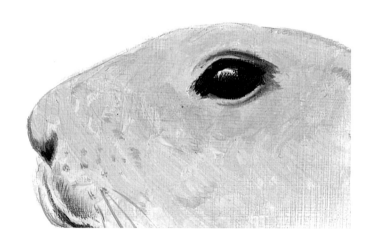

STEP 3: *Finish*

Use a clean no. 1 round to blend the dark edge of the eye
with the lighter fur color. Paint the eye highlight with a
mixture of Titanium White and a bit of Ultramarine Blue
on a no. 1 round. Blend the edges carefully into the dark
color of the eye with a clean no. 1 round. When the paint
is dry, carefully reestablish the highlight if it became too
dark during the blending stage. Use some of the color mix-
ture from step 2 to blend the shadows above and below the
eye into the surrounding fur. Using a no. 1 round and a
mixture of Titanium White and Cadmium Yellow Light,
lighten the lids above and below the eye. Lightly feather
the edges of the lids into the surrounding color.

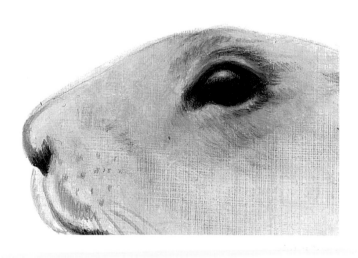

Mini-Demonstration

Prairie Dog Ears
GOUACHE ON ILLUSTRATION BOARD

MATERIALS

Colors	Yellow Ochre
Burnt Sienna	Zinc White
Burnt Umber	
Cadmium Red	**Brushes**
Pale	no. 0, 1, 2 and 3
Spectrum Yellow	rounds
Ultramarine Blue	no. 6 filbert

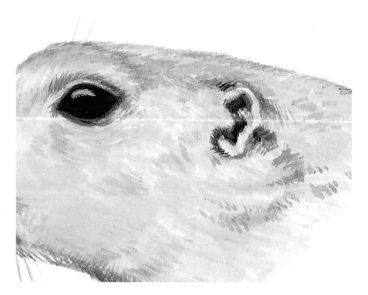

STEP 1: *Establish Form and Basic Color*

Lightly sketch the ear in pencil. Use Burnt Umber thinned with water and a no. 2 round to paint the basic forms. With a no. 2 round, paint the darkest parts of the ear using a mix of Burnt Umber and a small amount of Ultramarine Blue. Mix Zinc White, Yellow Ochre, a small amount of Spectrum Yellow and a touch of Cadmium Red Pale. Use a no. 3 round to paint a wash of this color over the ear and the surrounding area.

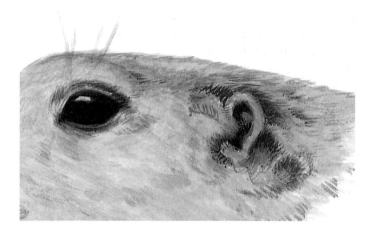

STEP 2: *Add Detail to Ear and Surrounding Fur*

Use a clean no. 2 round to mix a touch of Ultramarine Blue with a small amount of Burnt Umber and a bit of water. Use this color to paint the hair around the ear. Use short strokes following the fur pattern. Use a wash of this color to darken the inside of the ear. With a no. 6 filbert, carefully paint a thin wash of Burnt Sienna over the light body color.

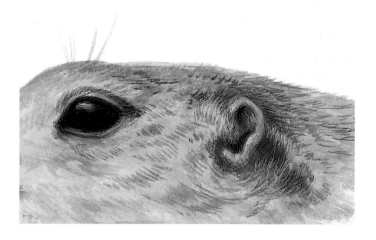

STEP 3: *Finish*

With a mixture of Zinc White and a small amount of Spectrum Yellow, use a no. 0 round to carefully apply highlights to the outer ear. Use a no. 1 round to blend the edges of these highlights with a wash of Burnt Sienna. With a mixture of Burnt Umber and Burnt Sienna and a no. 1 round, continue adding detail to the fur surrounding the ear, using strokes that follow the direction of hair growth. Reestablish the darkness inside the ear with a mixture of Burnt Umber and Ultramarine Blue and a no. 0 round.

Prairie Dog Nose and Whiskers
ACRYLIC ON GESSO-PRIMED MASONITE

MATERIALS

Colors	Brushes
Burnt Sienna	no. 1, 2 and 3
Burnt Umber	rounds
Titanium White	no. 6 filbert
Ultramarine Blue	
Yellow Oxide	

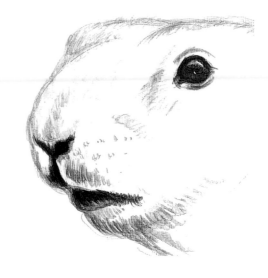

STEP 1: *Establish Basic Form and Values*

Lightly sketch the prairie dog's nose in pencil. Paint the basic values and forms using Burnt Umber thinned with water and a no. 2 round. Then, paint the darkest values with a mixture of Burnt Umber and Ultramarine Blue using a no. 1 round.

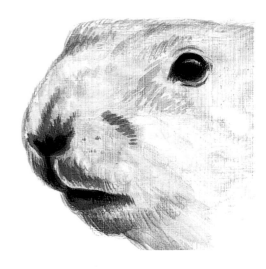

STEP 2: *Paint Middle Values*

Mix Burnt Umber, Ultramarine Blue and Titanium White for the middle values. Paint them with a no. 1 round. Use a no. 6 filbert to paint a thin wash of color—a mixture of Titanium White, Yellow Oxide and Burnt Sienna—over the remaining white area.

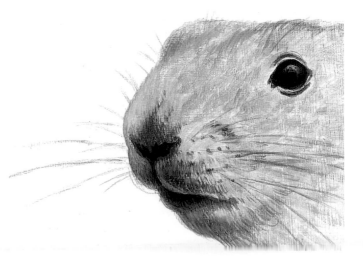

STEP 3: *Add Detail and Whiskers*

Blend the darkest areas with the middle-value areas using separate no. 1 rounds. Use short, fine strokes. Mix the lightest values with Titanium White and small amounts of Yellow Oxide and Burnt Sienna. Paint these light values above the nose with a no. 3 round. Mix a very light gray for the whiskers with Titanium White, Burnt Sienna and Ultramarine Blue. Use a fairly wet (but not too wet) no. 1 round to lightly stroke in the whiskers. Use very light pressure on the brush, making the pressure lighter toward the ends. Remember not to make the whiskers too regular or too evenly spaced.

Prairie Dog Feet
ACRYLIC ON GESSO-PRIMED MASONITE

MATERIALS	
Colors	Titanium White
Burnt Sienna	Ultramarine Blue
Burnt Umber	Yellow Oxide
Cadmium Orange	
Hansa Yellow	**Brushes**
Light	no. 0, 1, 2 and 3
Payne's Gray	rounds

STEP 1: *Establish Basic Form and Values*

Lightly sketch the prairie dog's feet in pencil. Use Payne's Gray thinned with water and a no. 2 round to paint the basic values, leaving the white of the panel for the lighter areas. Mix Burnt Umber and Ultramarine Blue and paint the claws and the shadows under and between the toes with a no. 0 round.

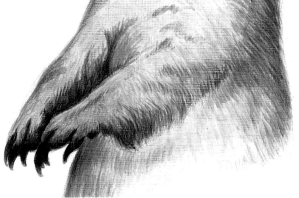

STEP 2: *Paint Middle Values*

Mix Titanium White, Yellow Oxide, Burnt Sienna and Cadmium Orange for the main fur color. Use a no. 2 round to paint the feet. Use small strokes of Burnt Umber thinned with water and a no. 1 round to blend the dark shadowed areas with the lighter areas.

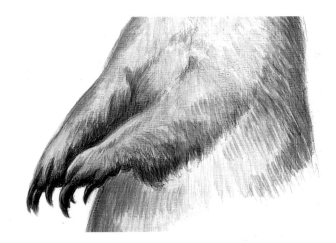

STEP 3: *Finish*

Mix Titanium White with small amounts of Ultramarine Blue and the dark mixture from step 1 to add highlights to the claws, using a no. 0 round. Use a separate no. 0 round and some of the dark claw color to carefully blend and soften the edges of the highlights. For the highlights along the edges of the paws, mix Titanium White, a small amount of the main body color mixture from step 2 and a touch of Hansa Yellow Light. Use a no. 3 round to paint these highlights. To soften the tips of the claws and make them look more realistic as they curve downward, use a no. 0 brush and a little of the color you mixed for the claw highlights. Carefully stroke this color onto the tips of the claws, and blend it into the dark color.

Prairie Dog
EBONY PENCIL ON ILLUSTRATION BOARD

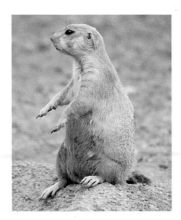

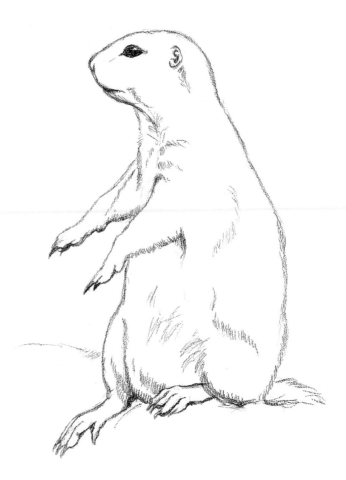

Reference Photo

STEP 1: *Sketch Main Lines*

Sketch the main lines first, showing the animal's form as well as lightly indicating the major fur patterns. It would be best to sketch the prairie dog first on a separate sheet of paper, so any mistakes can be corrected before transferring the image to the illustration board. Transfer the image to the illustration board with a piece of homemade transfer paper (see page 17).

STEP 2: *Establish Dark Values*

Begin sketching in the darker areas with your pencil. Sharpen the pencil to a fine point to shade the eye, feet and ears. As the point becomes more blunt, use it for the broader areas of fur. Use pencil strokes that follow the general direction of the hair growth.

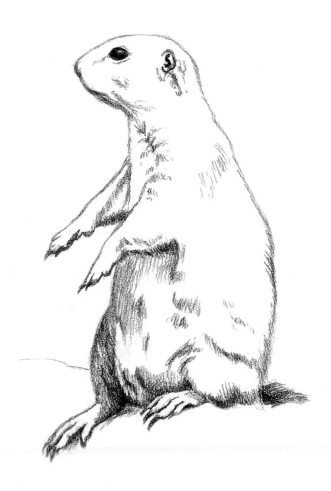

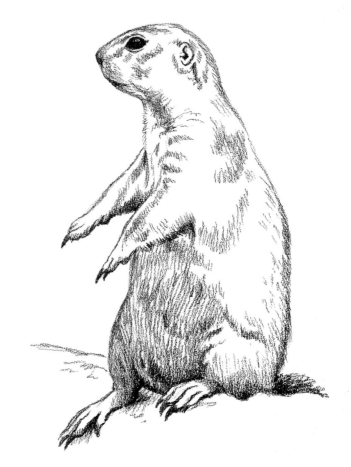

STEP 3: *Begin to Establish Middle Values*

Add more detail to the fur, using lighter pressure on the pencil for the middle values. Use shorter pencil strokes for the smaller details and longer strokes for the broader areas.

STEP 4: *Add Finishing Details and Soften With Stump*

Continue to add detail to the fur. Use a stump to selectively soften and blend the fur. Use it as if it were a pencil, rubbing it over the pencil lines in the same direction as the strokes. After the stump has become coated with pencil graphite, use the stump to draw new, softer lines. Use your kneaded eraser to lighten any place in the drawing that has become too dark. You can use the kneaded eraser like a pencil by molding it into a point with your fingers and drawing lighter hairs into the dark areas, or you can press the eraser lightly onto an area that has become too dark. The kneaded eraser will easily lift off some of the graphite; multiple pressings will remove more and more graphite.

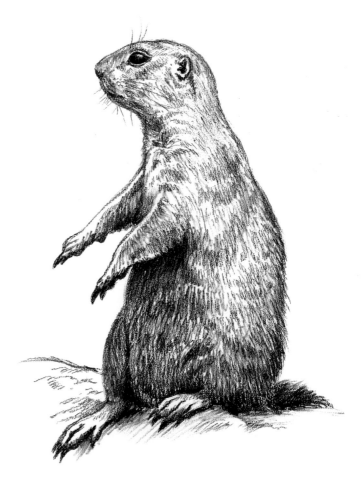

3

FOXES

There are four species of foxes in North America: the red fox, the gray fox, the kit fox and the arctic fox. The most widespread are the red and gray foxes. Red foxes have a slender build, long slim legs, large ears and a bushy, white-tipped tail. They may vary greatly in color. Some red foxes are a pale yellowish red, while others are a deep red on the upper parts of the body. They are usually white underneath, have a white-tipped tail and have black lower legs and ear tips. However, there are all-black "red" foxes as well as silver "red" foxes!

The gray fox is a little smaller and doesn't appear as long and slim as the red fox. It has a grizzled gray coat with rusty colored patches on the neck, belly, legs and tail. The muzzle is black, and the cheeks and throat are white. The tail has a black stripe down its length with a black tip. One interesting characteristic is that the gray fox, unlike the red fox, will climb trees, both to escape from enemies and to look for food.

Russet (detail)
Oil on panel
8" × 10" (20cm × 25cm)
Private collection

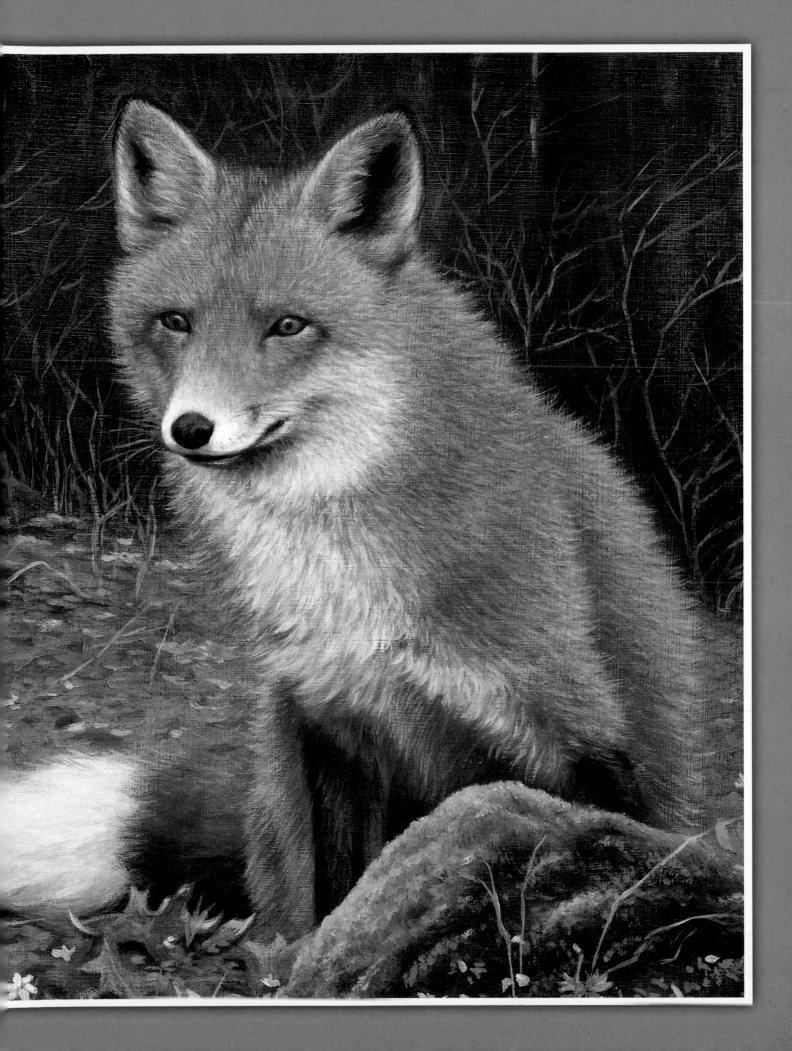

Typical Characteristics

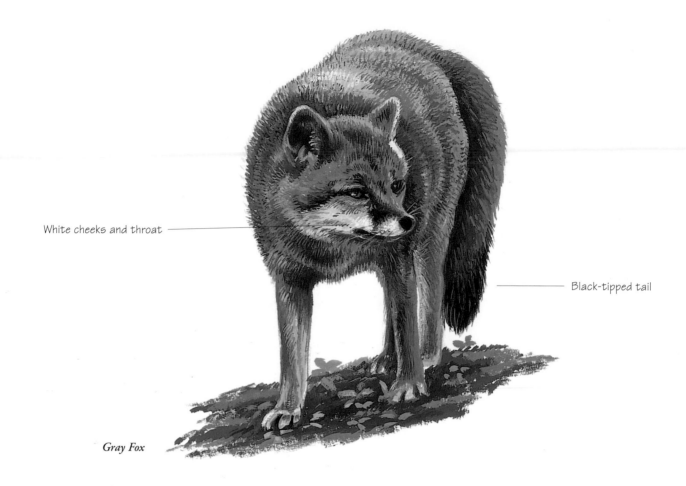

White cheeks and throat

Black-tipped tail

Gray Fox

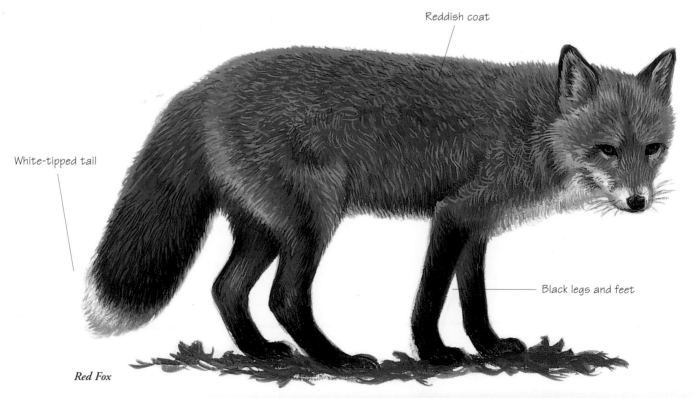

Reddish coat

White-tipped tail

Black legs and feet

Red Fox

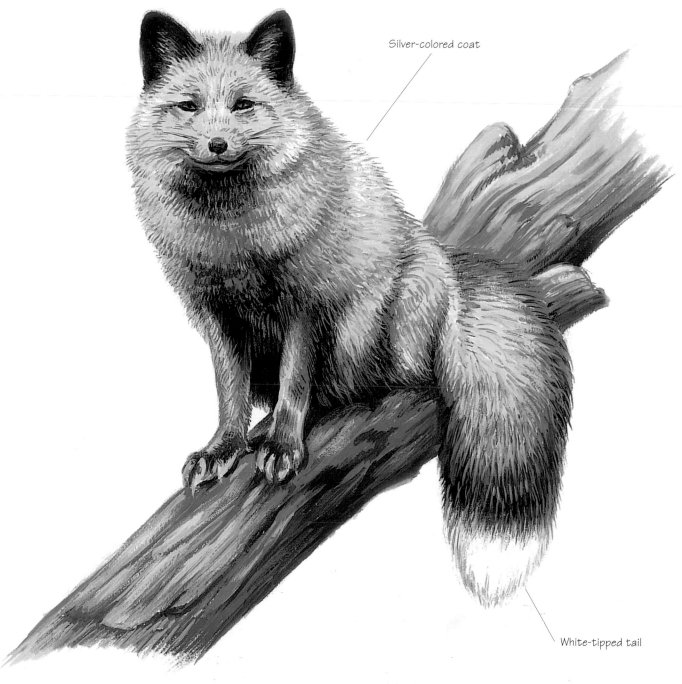

Silver-colored coat

White-tipped tail

Silver Fox

Red Fox Eyes

OIL ON GESSO-PRIMED MASONITE

MATERIALS

Colors	Titanium White
Burnt Sienna	Ultramarine Blue
Burnt Umber	Yellow Ochre
Cadmium	
Orange	**Brushes**
Cadmium Yellow	no. 0, 1 and 3
Light	rounds

STEP 1: *Paint Eye Shape and Dark Values*

Paint lines defining the eye shape with Burnt Umber thinned with turpentine and a no. 3 round. For the darkest value of the eyes, mix Burnt Umber and Ultramarine Blue. With a no. 3 round, paint the pupils and the dark lines around the eyes. Notice that a fox's pupils are vertical slits, similar to those of a house cat.

STEP 2: *Establish Basic Eye Color*

For the amber eye color, mix Yellow Ochre, Titanium White and a touch of Burnt Sienna. Apply with a no. 0 round. Begin to paint the surrounding fur. For the darker reddish color, mix Burnt Sienna, Cadmium Orange and Titanium White. For the lighter value, mix Titanium White, Cadmium Yellow Light, Cadmium Orange and a small amount of Burnt Sienna. Paint the two colors with separate no. 1 rounds.

STEP 3: *Round Out Eyes and Add Highlights*

Using separate no. 0 rounds with the dark value (from step 1) and the amber eye color, blend the edges of the dark pupils into the eye color. Then, blend the edges of the dark lines around the eyes into the eye color and into the fur surrounding the eye. Next, use a clean no. 0 round (no paint or medium) for finer blending. If you make a mistake—such as the pupil becomes the wrong shape—correct it by using a craft knife to carefully scrape away the paint, then repainting. Paint the eye highlights with Titanium White and a no. 0 round. Use another clean no. 0 round to carefully blend the edge of the highlight into the eye color.

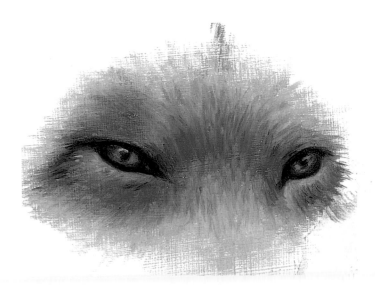

Red Fox Ears
ACRYLIC ON ILLUSTRATION BOARD

MATERIALS	
Colors	Titanium White
Burnt Sienna	Ultramarine Blue
Burnt Umber	
Cadmium	**Brushes**
Orange	no. 1 and 3
Cadmium Yellow	rounds
Light	

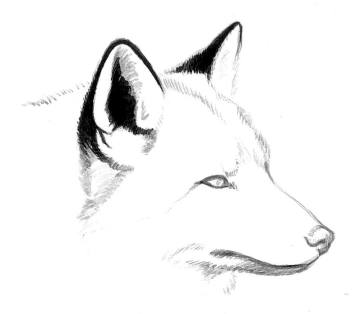

STEP 1: *Sketch Basic Lines and Paint Darkest Values*

Lightly sketch the head in pencil. Use a no. 3 round and Burnt Umber thinned with water to paint the main lines of the head. (From now on, use a small to moderate amount of water as your painting medium.) Mix Burnt Umber and Ultramarine Blue for the black around the edges of the ears. Paint with a no. 3 round, dipping your brush in water first, then into the paint. Let the paint dry, then paint another layer for a more intense dark. For the darkness inside the ear, use your no. 3 round and some Burnt Sienna mixed with the dark value.

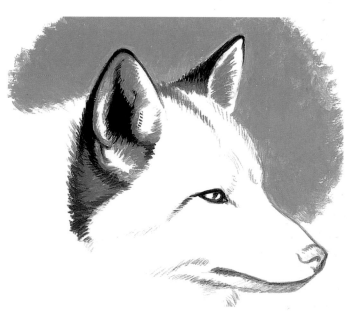

STEP 2: *Apply Middle Values*

For the reddish fur color, mix Titanium White, Cadmium Orange and Burnt Sienna. For the darker shadows in the fur, add some Burnt Umber and a little more Burnt Sienna. For the bluish shadows inside the ears, mix Titanium White, Ultramarine Blue, Burnt Umber and a little Burnt Sienna. Paint these middle values with separate no. 3 rounds, following the way the fur grows.

STEP 3: *Paint Lightest Values and Details*

For the white fur color inside the ears, mix Titanium White with a touch of Cadmium Yellow Light. Use a no. 3 round to paint, following the hair growth. Using a no. 1 round, overlap the darker areas bordering the white with short, sweeping brushstrokes to create the hairs inside the ear. Using a separate no. 1 round for each color, overlap areas where colors meet. Use a no. 1 round and some of the dark-value color to add detail to the bluish shadows inside the ears.

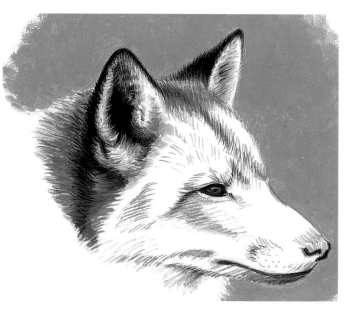

Red Fox Muzzle and Nose

OIL ON GESSO-PRIMED MASONITE

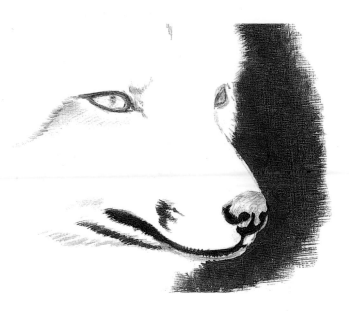

MATERIALS

Colors	Brushes
Burnt Sienna	no. 1 and 3
Burnt Umber	rounds
Cadmium	no. 2 and 4
Orange	filberts
Cadmium Yellow	
Light	
Titanium White	
Ultramarine Blue	

STEP 1: *Sketch Head and Establish Dark Values*

Do a light pencil sketch of the head. Next, use Burnt Umber thinned with turpentine and a no. 3 round (first dip the brush in turpentine, then in the paint), and paint the basic lines. For the darkest value color of the nose and muzzle, mix Burnt Umber, Ultramarine Blue and a touch of Titanium White. Paint with a no. 3 round.

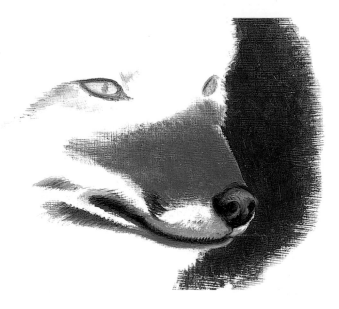

STEP 2: *Paint Middle Values*

For the reddish fur color, mix Burnt Sienna, Cadmium Orange and Titanium White. Use a no. 3 round to paint a fringe along the dark line of the mouth. For the reddish part of the muzzle, use a no. 2 filbert. Mix the bluish-gray color for the nose and for the shadowed part of the white muzzle area around the mouth with Titanium White, Burnt Umber and Ultramarine Blue. Paint with a no. 1 round. Blend the edges with another no. 1 round and some of the dark-value color you already mixed.

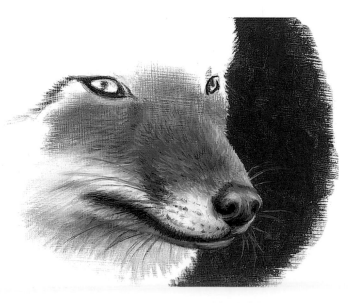

STEP 3: *Add Highlights and Details*

For the highlighted areas and for the white muzzle, mix Titanium White with a bit of Cadmium Yellow Light. Use a no. 4 filbert for broad areas, and a no. 1 round for small areas. Blend the edges with a no. 1 round by painting short strokes of the white mixture into the reddish fur. With another no. 1 round and some of the dark value, stroke some darker hairs into the reddish fur. For the whiskers against the dark background, mix Titanium White with a bit of the reddish fur color. For those overlapping the muzzle, use a bit of the dark value mixed with a little Titanium White. Use separate no. 1 rounds for each color.

Red Fox
GOUACHE ON ILLUSTRATION BOARD

MATERIALS

Colors	Yellow Ochre
Burnt Sienna	Zinc White
Burnt Umber	
Cadmium Yellow	**Brushes**
Deep	no. 1, 3 and 5
Spectrum Yellow	rounds
Ultramarine Blue	

Reference Photo

STEP 1: *Establish Form and Begin Painting Dark Values*

Lightly sketch the fox in pencil. Using a small amount of Burnt Umber thinned with water, sketch out the main lines of the fox with a no. 5 round. Mix the color for the black parts of the fox's coat with Burnt Umber and Ultramarine Blue. Paint with a no. 3 round. (From now on, use a small to moderate amount of water as you paint.) Mix the darkest value of the reddish coat color with Burnt Umber, Burnt Sienna and Zinc White. With a no. 3 round, paint these areas using fairly short, parallel brushstrokes that follow the contours of the fox's form, keeping in mind the way the hair grows.

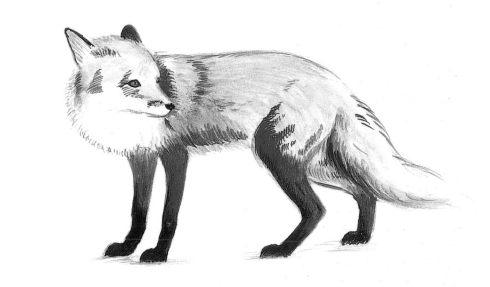

STEP 2: *Continue Painting Basic Coat Color*

Continue painting the basic reddish coat color using a no. 5 round for the broader areas. Use brushstrokes going in the direction of hair growth.

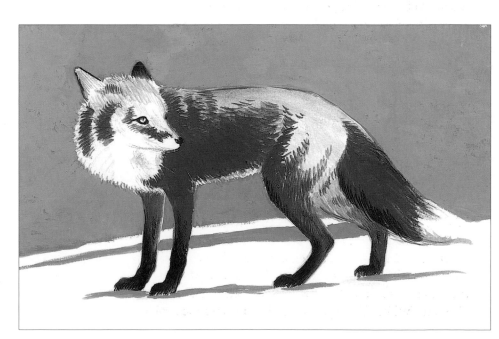

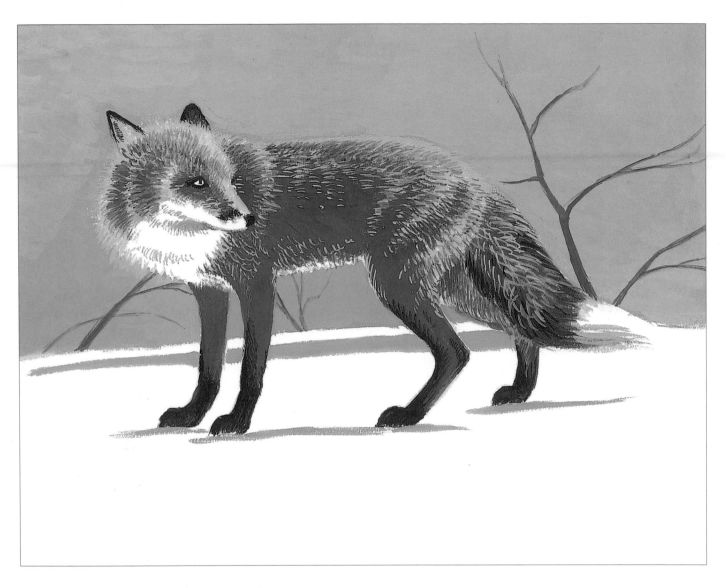

STEP 3: *Paint Lighter-Value Fur Color*

Mix the lighter-value fur color with Zinc White, Cadmium Yellow Deep and
Yellow Ochre. Paint with a no. 5 round, overlapping the edges where the lighter
and darker fur meet with short, parallel strokes.

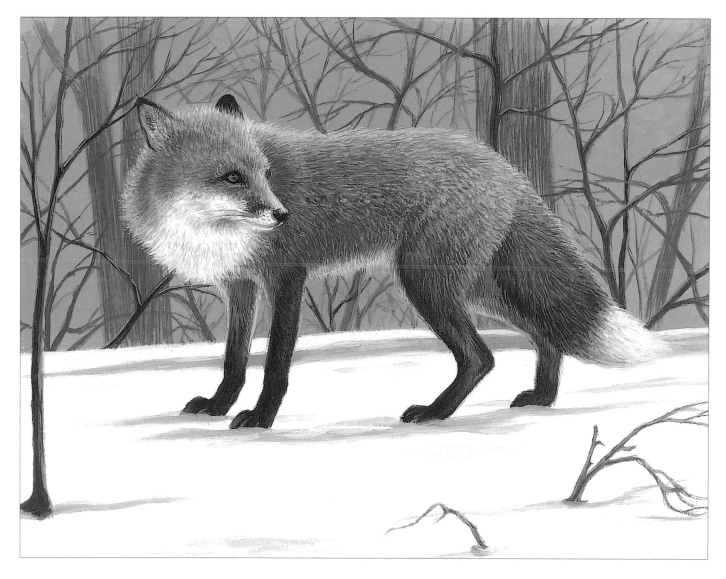

STEP 4: *Add Finishing Details*

Paint hair detail in the areas of darker reddish fur using a no. 3 round and some of the lighter fur color you already mixed. Use short, thin brushstrokes that follow the hair pattern. With a separate no. 3 round and the dark reddish fur color, add some hair detail on top of the lighter fur color. Hold both brushes in your hand at the same time so you can work back and forth on these areas. Soften and integrate the lighter fur detail using a no. 3 round and a small amount of the dark reddish fur color mixed with enough water to make a glaze. Paint over the lighter fur detail so that it shows through the glaze, using quick, light brushstrokes.

Mix a little Spectrum Yellow with Zinc White and use a no. 1 round to warm and intensify some of the highlighted areas on the fox's coat. Add small details such as the eyes, nose, whiskers and fine fur detail with a no. 1 round.

Tip

Soften and smooth out any areas of fur that seem to need it using a no. 3 round and water. Carefully stroke in the same direction as the existing brushstrokes. You can still wet and blend gouache even after it is dry.

Gray Fox Eyes
ACRYLIC ON ILLUSTRATION BOARD

MATERIALS	
Colors	Titanium White
Burnt Sienna	Ultramarine Blue
Burnt Umber	
Cadmium	**Brushes**
Orange	no. 1 rounds

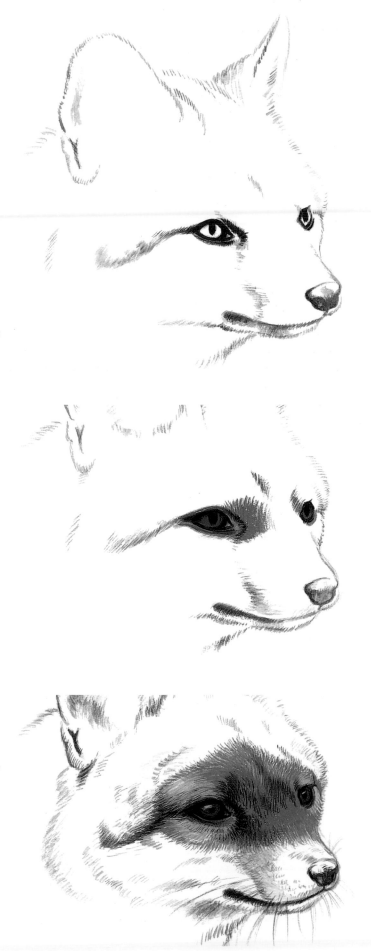

STEP 1: *Establish Main Lines and Dark Values*

Use Burnt Umber thinned with water to establish the basic lines. Mix Burnt Umber and Ultramarine Blue for the darkest-value color—the pupils and the outline of the eyes. Dip the no. 1 round first in water and blot it on a paper towel before dipping into your paint. (From now on, use a small to moderate amount of water as you paint.)

STEP 2: *Paint Basic Eye Color and Surrounding Fur*

Mix the eye color with Cadmium Orange, Burnt Sienna and Titanium White. Use enough water so the paint flows easily. With another no. 1 round, blend the pupil and the edge of the eye with this color. Mix the bluish-gray color for the fur around the eyes with Ultramarine Blue, Titanium White and Burnt Umber. Paint around the outer lines of the eyes with some of the eye color you just mixed.

STEP 3: *Refine Eyes and Add Highlights*

Continue refining the detail of the eyes, using separate brushes for each color. When painting the fur, blend one color into the other with short strokes following the fur growth pattern. For the eye, use smooth strokes that follow the curve of the eyeball. Mix the color for the highlight in the eye with Titanium White and a bit of the bluish-gray fur color you mixed in step 2, plus a little more Ultramarine Blue. Paint the highlight in a curving arc. Blend the dark edges of the eye into the reddish-brown eye color using separate brushes.

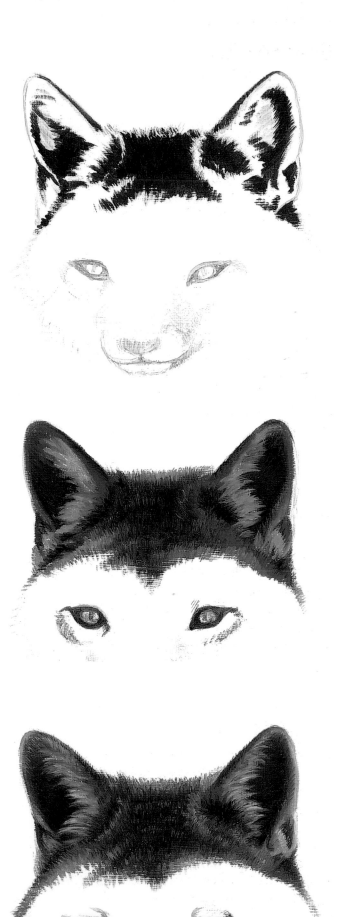

Mini-Demonstration

Gray Fox Ears
OIL ON GESSO-PRIMED MASONITE

MATERIALS

Colors	Titanium White
Burnt Sienna	Ultramarine Blue
Burnt Umber	Yellow Ochre
Cadmium	
Orange	**Brushes**
Cadmium Red	no. 0, 1 and 3
Light	rounds
Payne's Gray	no. 2 filbert

STEP 1: *Sketch Basic Lines and Establish Dark Values*

Paint the basic lines with Payne's Gray thinned with turpentine and a no. 1 round. Mix the darkest-value color for the ears with Burnt Sienna and Ultramarine Blue. Paint using a no. 1 round. Mix the steely blue-gray color for around the base of the ears and between the ears with Burnt Umber, Ultramarine Blue and a bit of Titanium White. Use a no. 2 filbert to paint this area.

STEP 2: *Paint Middle Values*

Use a no. 1 round to paint the reddish pink color inside of the ears with Burnt Sienna, Cadmium Red Light, Titanium White and a bit of Burnt Umber. Blend into the surrounding color. Mix the rust color for the fur around the base and edges of the ears with Burnt Sienna, Cadmium Orange and Titanium White. Paint with a no. 2 filbert. Blend the edges with a no. 1 round. Paint the fur's bluish-gray middle value with Ultramarine Blue, Titanium White and Burnt Umber using a no. 3 round, then blend into the dark fur around it. Using a no. 1 round with the same color, paint the inside ear hairs with sweeping, slightly curving strokes to overlap the hair tufts against the darkness inside the ears.

STEP 3: *Add Highlights and Detail*

Mix the highlight color with Titanium White, Yellow Ochre and a bit of Cadmium Orange. Use a no. 0 round to paint the highlights on the hair inside the ears. When dry, reinforce the highlights on the tips of the ear tufts so they stand out against the darkness inside the ears. Add detail to the dark grayish fur between the ears using the blue-gray color from step 2 and a no. 1 round. Use another no. 1 round to blend the edges with the dark fur.

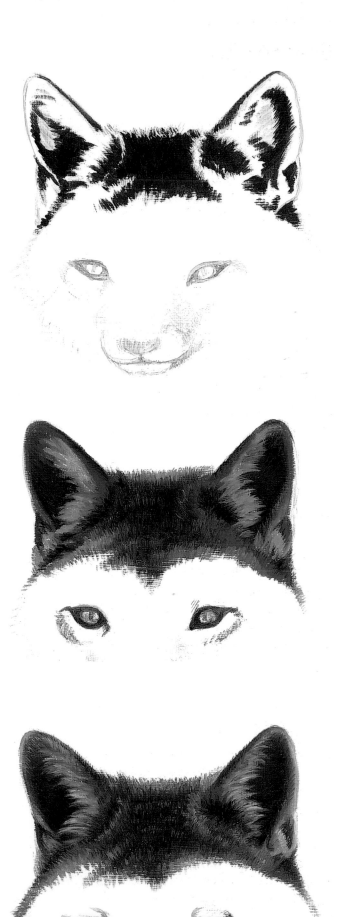

Gray Fox Nose and Muzzle
ACRYLIC ON ILLUSTRATION BOARD

MATERIALS

Colors	Brushes
Burnt Sienna	no. 1 and 3
Burnt Umber	rounds
Cadmium	
Orange	
Titanium White	
Ultramarine Blue	

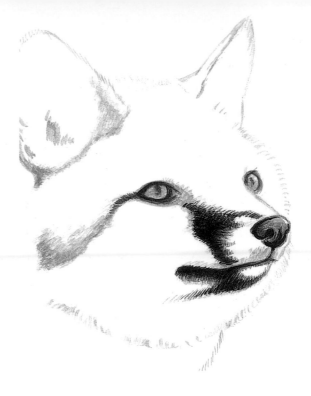

STEP 1: *Establish Basic Lines and Dark Values*

Lightly sketch the head in pencil. Use Burnt Umber
thinned with water and a no. 3 round to paint the basic
lines. Mix the black for the muzzle, nose and chin with
Burnt Umber and Ultramarine Blue. Paint with a no. 1
round, first dipping the tip of the brush in water. (From
now on, use a small amount of water as you paint.)
Follow the way the fur grows.

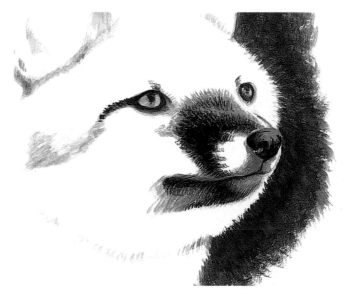

STEP 2: *Paint Middle Values*

Mix the two middle-value colors. For the blue-gray fur,
mix Titanium White, Ultramarine Blue and Burnt
Umber. For the rusty reddish color, mix Titanium White,
Cadmium Orange and Burnt Sienna. Use separate no. 1
rounds to paint these areas. With another no. 1 round and
the dark value you already mixed, overlap the edges where
the middle and dark values meet. Use short parallel brush-
strokes that follow the fur pattern.

STEP 3: *Add Highlights and Details*

Use no. 1 rounds to finish. With the blue-gray color, paint
more hair detail in the dark fur areas. Paint the white parts
of the muzzle with Titanium White. Mix a small amount
of the dark value color with Titanium White and overlap
the white edges. Use the same color and brush to paint the
whiskers that overlap the fox's body, with enough water on
the brush to make the paint flow. For the whiskers that
overlap the dark background, use Titanium White. Blend
the edges where the white part of the muzzle meets the
rusty color, alternating between the two colors.

Demonstration

Gray Fox
OIL ON GESSO-PRIMED MASONITE

MATERIALS

Colors	Payne's Gray
Burnt Sienna	Titanium White
Burnt Umber	Ultramarine Blue
Cadmium	
Orange	**Brushes**
Cadmium Red	no. 0, 1 and 3
Light	rounds
Cadmium Yellow	no. 2 filbert
Light	

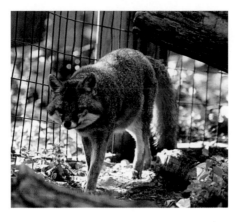

Reference Photo

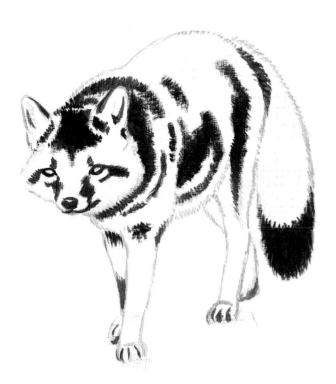

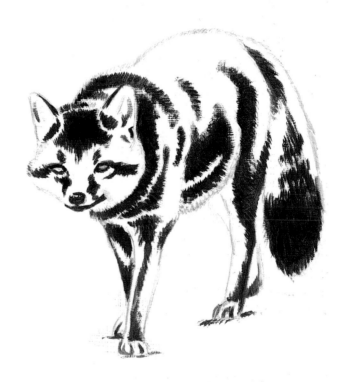

STEP 1: *Establish Main Lines and Begin Coat*

Lightly sketch the fox in pencil. Paint the main lines over this sketch using Payne's Gray thinned with turpentine and a no. 3 round. For smaller details use a no. 1 round. Mix the darkest shadows for the gray part of the coat with Burnt Umber and Ultramarine Blue. Paint with a no. 2 filbert, using dabbing strokes that follow the hair pattern. For details, such as the hair tufts at the end of the tail and facial features, use a no. 3 round.

STEP 2: *Continue Coat*

For the rust-colored parts, mix Titanium White, Burnt Sienna and Cadmium Orange. (You'll use this color in step 3.) Transfer some of this color to a clean spot on your palette and mix with some Burnt Umber and a little Ultramarine Blue for the dark shadows in the rusty areas. Use a no. 3 round. In places such as the dark shadow along the belly and under the ruff around the neck, you'll paint the dark rusty red adjacent to and overlapping the edges of the dark shadowed areas you painted in the first step.

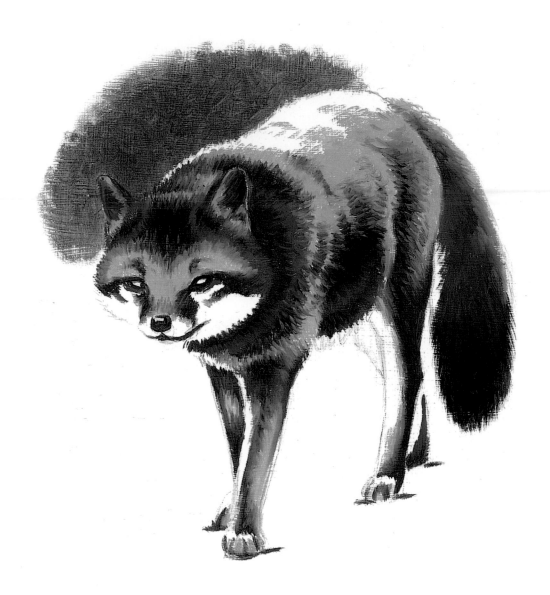

STEP 3: *Paint Middle Values*

Paint the rusty red part of the fox's coat with a no. 3 round. Use another no. 3 round and some of the blackish color from step 1 to blend the edges of the rusty red areas where the two colors meet. For the blue-gray middle value of the coat, mix Titanium White, Ultramarine Blue and Burnt Umber. Paint with a no. 3 round and follow the hair growth pattern.

Use separate no. 3 rounds for the rusty red middle value and the dark value, and blend the edges where the two colors meet. Use short brushstrokes to create the look of fur. If a brush gets too much of the other color on it, wipe it on a paper towel, then dip into the correct color again.

Mix the pinkish color for the inside of the ears with Cadmium Red Light, Burnt Umber, Burnt Sienna and Titanium White.

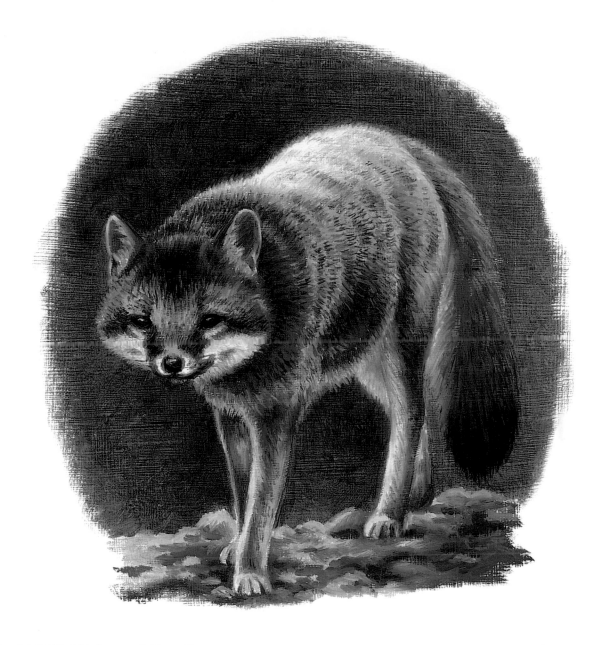

STEP 4: *Add Highlights and Details*

Mix the color for the warm highlights along the tail, upper legs and chest with Titanium White, Cadmium Yellow Light, Cadmium Orange and a bit of Burnt Sienna. Paint with a no. 3 round. Use a clean no. 3 round to blend the highlight color into the surrounding color. For the brightest highlights along the fox's back, ears, lower legs and feet, muzzle and cheeks, mix Titanium White and a small amount of Cadmium Yellow Light and use a no. 3 round.

When dry, add some fur detail over the blue-gray middle-value fur with a no. 0 round and some of the dark color mixture from step 1. Use another no. 0 round and some of the blue-gray color from step 3 to tone down and blend the dark hairs with the surrounding color.

Paint the eyes with a no. 0 round and the dark shadow color from step 1. Use a separate no. 0 round and a mixture of Titanium White and a bit of Ultramarine Blue to carefully paint the eye highlights.

4

RACCOONS AND WOODCHUCKS

Raccoons are intelligent animals that can adapt to a variety of environments, including urban areas. Their most striking feature is the black mask, which is surrounded by white fur. Its fur color ranges from gray to black, with black and white banded guard hairs and short grayish or brownish underfur. The raccoon appears in Native American folklore as a trickster who can outsmart his enemies and use his hands like a human.

Also called the ground hog or whistle pig because of its habit of whistling shrilly when alarmed, the woodchuck is actually an oversized squirrel belonging to the marmot family. Commonly seen in farm fields, where they enjoy sunbathing outside their burrows after a meal, woodchucks are also often seen feeding by roadsides. It has a bushy tail of medium length and strong claws used for digging.

Caught Out
Acrylic on illustration board
6" × 12" (15cm × 30cm)
Collection of the artist

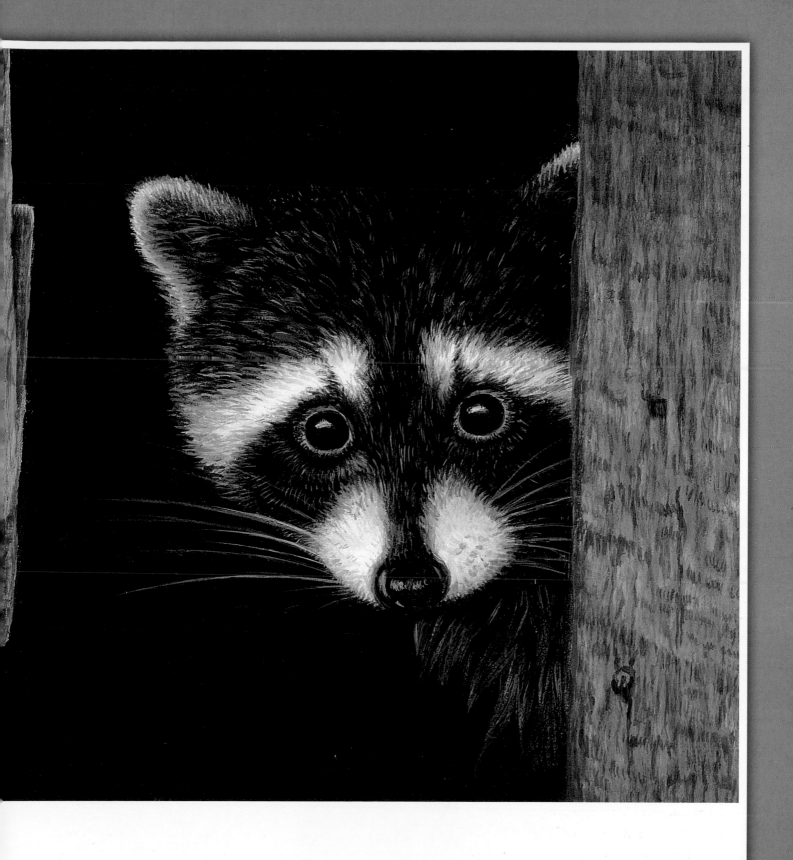

Typical Characteristics

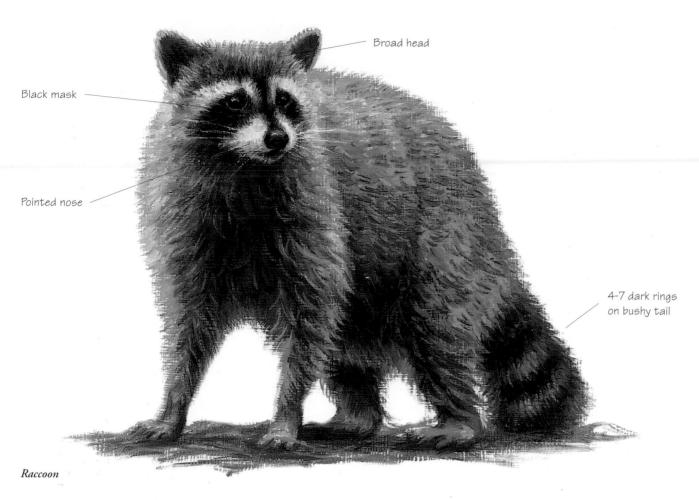

Broad head

Black mask

Pointed nose

4-7 dark rings on bushy tail

Raccoon

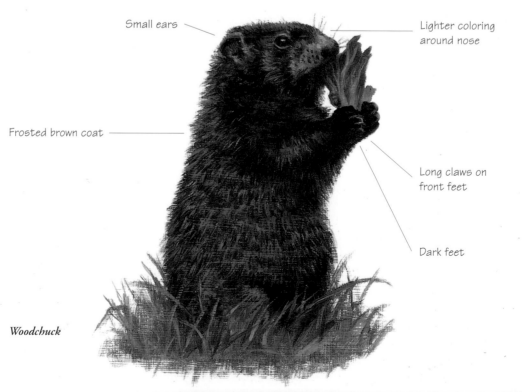

Small ears

Lighter coloring around nose

Frosted brown coat

Long claws on front feet

Dark feet

Woodchuck

Raccoon Eyes and Mask
ACRYLIC ON ILLUSTRATION BOARD

MATERIALS

Colors	Brushes
Burnt Umber	no. 1 and 3
Cadmium	rounds
Orange	no. 6 filbert
Raw Sienna	
Titanium White	
Ultramarine Blue	
Yellow Oxide	

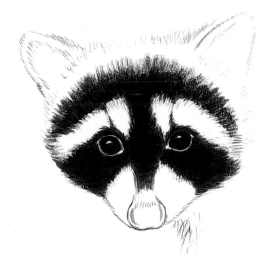

STEP 1: *Sketch Basic Lines and Paint Dark Areas*

Lightly sketch the head in pencil. Paint the basic lines and shapes with a no. 3 round and a mixture of Burnt Umber and Ultramarine Blue thinned with water. (From now on, use a small to moderate amount of water on your brush, unless otherwise indicated.) Mix Burnt Umber and Ultramarine Blue for the dark parts of the mask. Paint the mask with a no. 6 filbert (broad areas) and a no. 3 round (smaller areas). As the paint dries, add another coat. For the eyes, mix more Burnt Umber into a small amount of the black you just mixed. Paint with a no. 1 round, leaving white for the highlights.

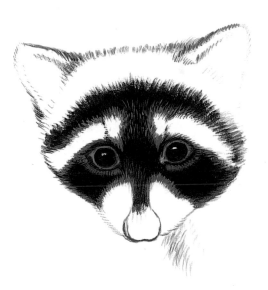

STEP 2: *Begin Adding Middle Value Fur Detail*

Paint the bluish fur highlights with a mixture of Ultramarine Blue, Titanium White and a bit of Burnt Umber. Use a no. 3 round and enough water so the paint flows. Paint this color around the eyes and at the edges where the black fur transitions to white fur. In the dark area between the eyes and on the forehead, which has a salt-and-pepper pattern, paint vertical, slightly curving strokes of the bluish color. Vary the length of your strokes slightly. Mix the brownish color for the edges of the mask and underneath the eyes using Titanium White, Raw Sienna and a touch of Cadmium Orange. Paint with a no. 1 round, overlapping the edges of the mask.

STEP 3: *Paint White Fur and Add More Detail*

Use no. 1 rounds to finish. Paint around the edges of the eyes with some of the dark brown eye color to reestablish the eye shape and to soften the line around it. Continue to paint strokes of the bluish color into the black fur. Soften by painting lightly over them with a moist brush and some of the black fur color. For the fur above the eyes, mix Titanium White and a bit of Yellow Oxide. Use a no. 3 round, but switch to a no. 1 round to paint white tufts overlapping the black fur. Add some dark, staggered lines with the black mask color from step 1 diluted with water. Paint the eye highlights with the bluish color and Titanium White. When dry, add a small dot of Titanium White.

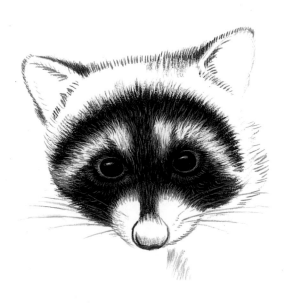

Raccoon Nose and Whiskers

GOUACHE ON ILLUSTRATION BOARD

MATERIALS

Colors	Brushes
Burnt Umber	no. 0 and 3
Ultramarine Blue	rounds
Zinc White	no. 2 filbert

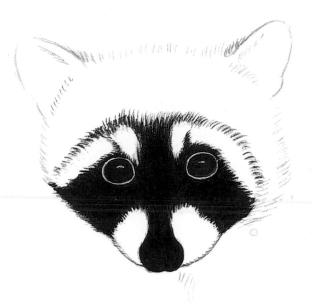

STEP 1: *Establish Shape and Paint Dark Values*

Lightly sketch the head in pencil. Paint the main lines with a no. 3 round and Burnt Umber thinned with water. Mix Burnt Umber and Ultramarine Blue for the black nose and mask, painting with a no. 2 filbert. (From now on, use a small to moderate amount of water on your brush unless otherwise indicated.)

STEP 2: *Begin Painting Middle Values*

For the bluish highlights on the nose and black mask, mix Ultramarine Blue, Zinc White and a small amount of Burnt Umber. Paint a fringe of this color with a no. 0 round around the edges of the black mask, a line around the edge of the nose and around the eyes, and the high-lights on the nose. Mix the brownish color for around the edges of the mask and underneath the eyes with Burnt Umber and Zinc White. Paint with a no. 0 round.

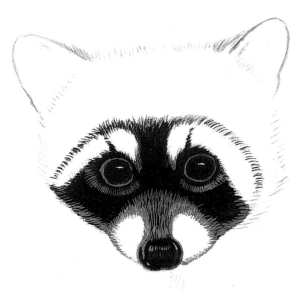

STEP 3: *Add Details*

Use a no. 0 round and the bluish color to paint lighter hairs on the black stripe going down to the nose. Paint some brownish hairs interspersed with the bluish hairs on the black stripe. Paint a brownish line around the edge of the nose to soften it, then use a moist brush to blend. Mix some Zinc White with the brownish color for the reflected color on the left side of the white muzzle and on the right side around the black band and nose. Use a no. 3 round.

Paint the whiskers with a no. 0 round and Zinc White, using enough water so you can paint a single smooth, curving stroke. For the ends overlapping the background, switch to the brownish color mixed with more Zinc White, diluted until very light. Correct any whiskers overlapping the black mask with a separate no. 1 round and the black color mixture.

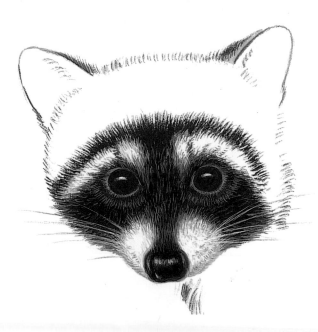

Raccoon Ears
OIL ON GESSO-PRIMED MASONITE

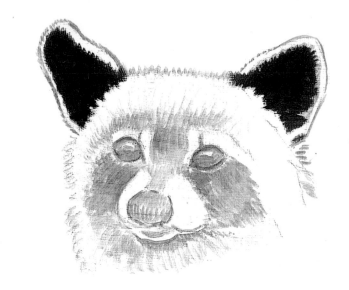

MATERIALS	
Colors	Titanium White
Burnt Sienna	Ultramarine Blue
Burnt Umber	
Cadmium	**Brushes**
Orange	no. 0, 1 and 3
Cadmium Yellow	rounds
Light	no. 2 filbert
Raw Sienna	

STEP 1: *Paint Main Forms and Dark Values*

Sketch the head lightly in pencil. With a no. 3 round and Burnt Umber thinned with turpentine, paint the main lines and shapes. Mix the dark color for the inside of the ears with Burnt Umber and Ultramarine Blue. Paint with a no. 2 filbert.

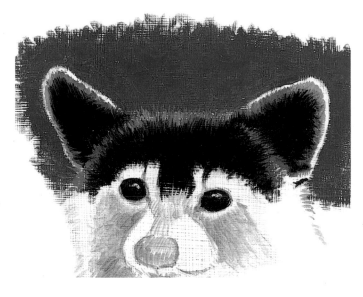

STEP 2: *Paint Middle Values*

Mix the blue-gray shadow color for the outer edges of the ears with Titanium White, Ultramarine Blue and Burnt Umber. Paint with a no. 3 round, using strokes that overlap the edge of the dark area. Mix the brownish color with Titanium White, Raw Sienna and small amounts of Cadmium Orange and Burnt Sienna. Paint with a no. 1 round, following the hair growth.

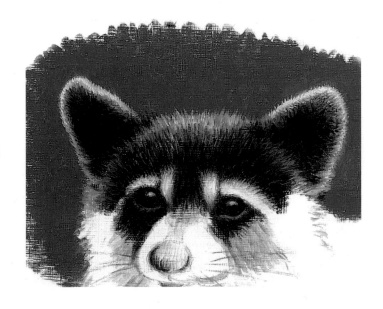

STEP 3: *Add Highlights and Fur Detail*

Using a no. 0 round, paint the white ear fringe with Titanium White and a bit of Cadmium Yellow Light. (Adding a touch of yellow will warm up the white and make it stand out against the surrounding colors.) Make the outer edges of the ears fuzzy by painting small parallel brushstrokes out from the ear against your background. Blend the edges where the colors meet using separate no. 1 rounds for each color.

Raccoon Feet
ACRYLIC ON ILLUSTRATION BOARD

MATERIALS	
Colors	**Brushes**
Burnt Umber	no. 0 and 1
Titanium White	rounds
Ultramarine Blue	

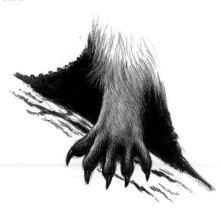

Close-Up of a Raccoon's Left Front Foot
Raccoons have five toes on each foot, joined by a membrane that extends about a third of the way down. The hind feet are quite a bit longer than the forefeet.

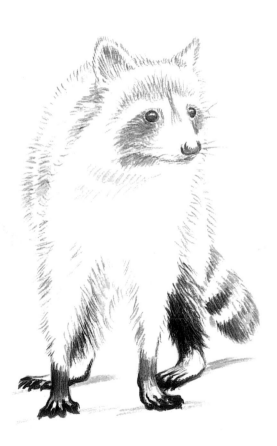

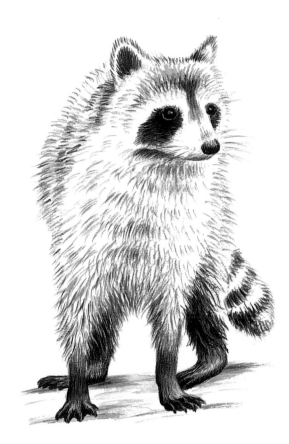

STEP 1: *Establish Basic Lines and Dark Values*

Lightly sketch the raccoon in pencil. Paint the main lines with a no. 1 round and Burnt Umber thinned with water. Mix Burnt Umber and Ultramarine Blue for the dark shadow color of the feet. Paint the dark areas with a no. 1 round. (From now on, use a small to moderate amount of water as your medium, unless otherwise indicated.)

STEP 2: *Paint Middle Values and Add Highlights and Detail*

For the middle-value grayish brown color, mix Titanium White and small amounts of Burnt Umber and Ultramarine Blue. Paint with a no. 0 round, using small brushstrokes that follow the contour of the feet. For the highlights, add more Titanium White to some of the middle-value color. Using separate no. 0 rounds, blend the edges where the colors meet.

Raccoon Tail
OIL ON GESSO-PRIMED MASONITE

MATERIALS	
Colors	Ultramarine Blue
Burnt Umber	Yellow Ochre
Cadmium	
Orange	**Brushes**
Raw Sienna	no. 1 and 3
Titanium White	rounds

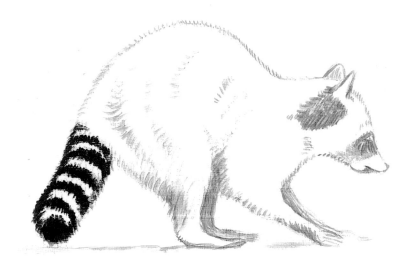

STEP 1: *Establish Main Lines and Dark Value*

Sketch the raccoon lightly in pencil. Paint the main lines with Burnt Umber thinned with turpentine and a no. 3 round. Mix Burnt Umber and Ultramarine Blue for the dark rings. Paint them with a no. 1 round. Paint the tail rings with parallel brushstrokes and so they curve around the tail.

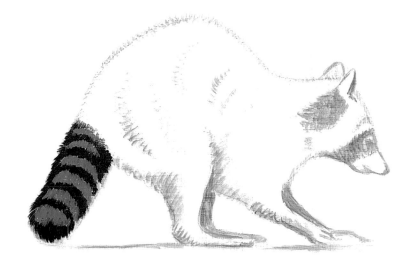

STEP 2: *Paint the Middle Value*

To mix the middle value between the dark tail rings, use Titanium White, Raw Sienna and a touch of Cadmium Orange. Paint with a no. 3 round, using parallel strokes that follow the way the hair grows. Wipe your brush on a paper towel every so often to remove the dark tail ring color that will get on your brush as you paint.

STEP 3: *Blend Edges and Add Highlights*

With separate no.1 rounds, blend the edges of the black rings with the lighter colored rings. Use uneven, linear brushstrokes to give the impression of fur. Wipe your brush frequently on a paper towel to clean off the lighter color when it becomes contaminated. If a black ring becomes too light, reestablish the black by painting over it. Blend and reestablish the lighter color as necessary. Mix Titanium White with a bit of Yellow Ochre for the highlights. Paint with a no. 1 round over parts of the middle-value color with short brushstrokes. Be sure that you do not cover it completely.

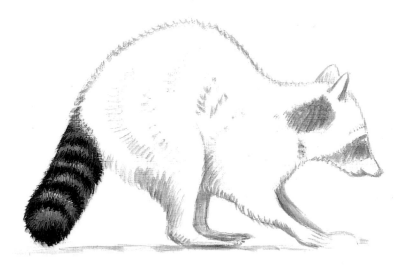

Raccoon
OIL ON GESSO-PRIMED MASONITE

MATERIALS

Colors	Brushes
Burnt Sienna	no. 0, 1 and 3
Burnt Umber	rounds
Raw Sienna	no. 4 filbert
Titanium White	
Ultramarine Blue	
Yellow Ochre	

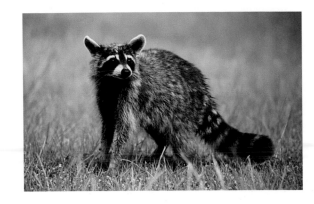

Reference Photo

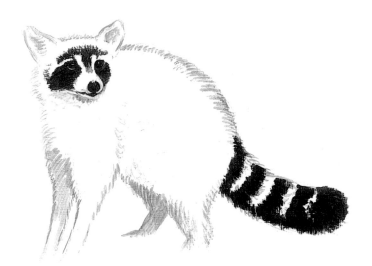

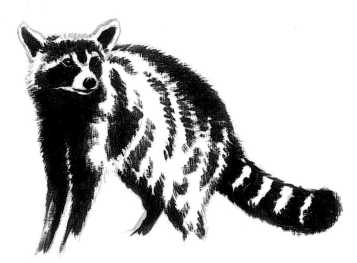

STEP 1: *Establish Main Lines and Paint Darkest Value*

Lightly sketch the raccoon in pencil. Use Burnt Umber thinned with turpentine and a no. 3 round to roughly paint the basic lines. For the black mask and tail rings, mix Burnt Umber and Ultramarine Blue. Paint the tail rings with a no. 4 filbert. Paint the mask, eyes and nose with a no. 1 round.

STEP 2: *Paint Darker Value of Coat*

Mix the brownish shadow color for the raccoon's coat with Burnt Umber and a smaller amount of Ultramarine Blue than you used to mix the black in step 1, plus a very small amount of Titanium White. In areas of fur that are a confusing mixture of dark fur overlaid with very small lighter colored hairs, such as the left foreleg, first paint the area dark. Later on, you can paint the lighter hairs over the dark fur.

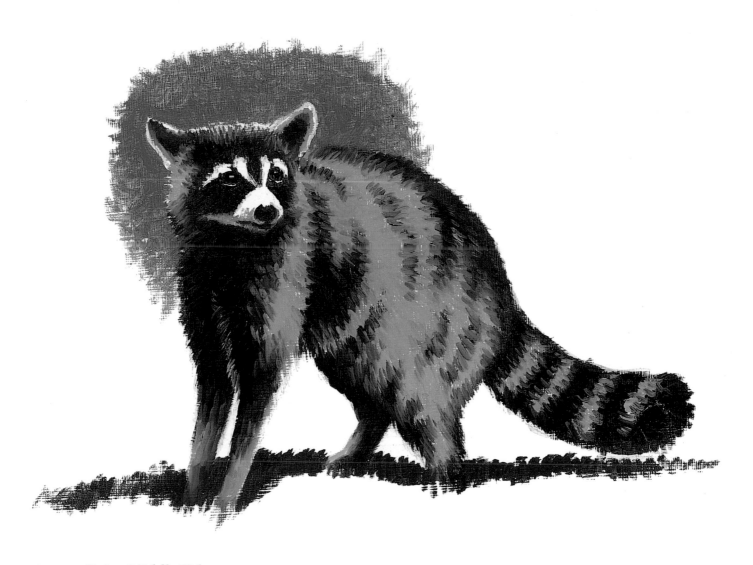

STEP 3: *Paint Middle Values*

Mix the grayish brown middle-value coat color with Titanium White, Burnt Umber and a smaller amount of Raw Sienna. Paint with a no. 3 round, using short, parallel brushstrokes following the fur pattern. With a separate no. 3 round and the dark-value color you mixed in step 2, begin to blend the edges where the two colors meet.

For the bluish shadow color on the lower part of the muzzle, around the edges of the ears and for the top of the lower part of the right leg, mix Titanium White, Ultramarine Blue and a small amount of Burnt Umber.

Tip

If you make a mistake when painting a detail, such as the eye, and you need to change the shape, use the tip of a craft knife to scrape the paint away. If you want to remove the paint completely, use a cotton swab dipped in turpentine to rub the paint carefully away. In this way, you can make corrections without disturbing the other parts you've already painted.

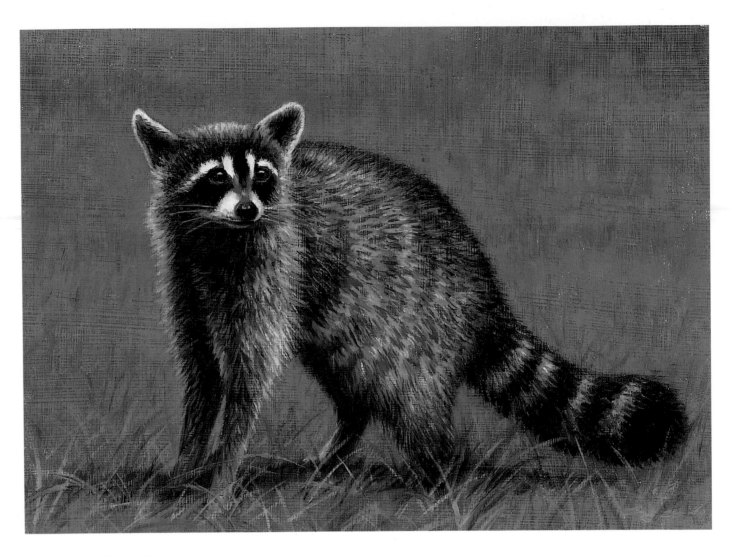

STEP 4: *Add Details*

Continue blending the dark and middle values of the fur using separate no. 3 rounds. Wipe the brushes on a paper towel when they get too much of the opposite color on them, then redip them first in Liquin then in the correct color. For the brownish color on either side of the dark band between the eyes and down the length of the muzzle, use a no. 1 round with a bit of the middle-value color mixed with Burnt Umber and Burnt Sienna. Use a no. 0 round with Titanium White and a small amount of Yellow Ochre for the white fur on the muzzle, above the eyes and outlining the ears. Use a no. 1 round with the brownish color to blend the edges. Get some of the bluish shadow color on your brush and blend where the white meets the bluish color.

When dry to the touch, mix a little of the dark-value brownish color from step 2 with a little of the middle-value color from step 3. Use a no. 1 round to paint fur detail over the light and dark parts of the coat. Paint

clumps of fur rather than individual hairs; make them roughly triangular in shape. With separate no. 1 rounds for the dark and middle values, blend and add fur detail. Reestablish darks where needed. Paint a few brownish hairs over the black tail bands and the mask so they will integrate with the rest of the coat.

Mix the wheaten coat highlights with Titanium White and a touch of Yellow Ochre. With a no. 1 round, highlight the clumps of fur. Use separate brushes with the other fur colors to blend the edges where the colors meet. With a no. 0 round, take some of the bluish color mixture from step 3 and mix with some Titanium White to paint the eye highlights. Paint the whiskers with a no. 0 round and the Titanium White–Yellow Ochre mixture. Add a few tufts of the wheaten color to the raccoon's coat using a no. 1 round. Putting some of your background color into the coat will integrate the animal with its surroundings.

Woodchuck Eyes
OIL ON GESSO-PRIMED MASONITE

Colors	Brushes
Burnt Sienna	no. 5/0, 0 and 3
Burnt Umber	rounds
Titanium White	
Ultramarine Blue	
Yellow Ochre	

STEP 1: *Establish Form*

Sketch the head lightly in pencil. Paint the main form of the head with Burnt Umber thinned with turpentine and a no. 3 round.

STEP 2: *Paint Basic Colors for Eye and Surrounding Fur*

Mix the dark brown color for the eye with Burnt Umber and Ultramarine Blue. Paint the eye with a no. 0 round. Leave a white space for the highlight. Paint the lids above and below the eye with a little of the eye color mixed with some more Burnt Umber and a no. 0 round. Mix the color for the lighter brown fur surrounding the eye with Titanium White, Yellow Ochre and Burnt Sienna. Paint above and below the eye with a no. 0 round, switching to a no. 3 round for the broader areas.

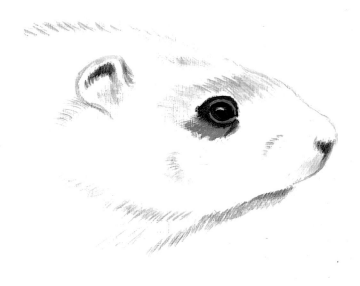

STEP 3: *Paint Eye Highlight and Add Details*

Using a no. 0 round, paint the eye highlight with Titanium White and a small amount of Ultramarine Blue. Use another no. 0 round with some of the dark eye color to blend the edges of the highlight. Brighten the highlight by painting a small curve over the middle of the highlight with a no. 5/0 round and Titanium White. Using separate no. 0 rounds for each color, blend the eyelids at the edges where they meet both the eyeball and the fur around the eye. Finish painting the light and the dark fur around the eye with no. 3 rounds, blending the edges and reestablishing colors where needed.

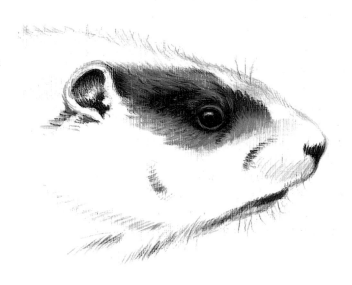

Woodchuck Ears

OIL ON GESSO-PRIMED MASONITE

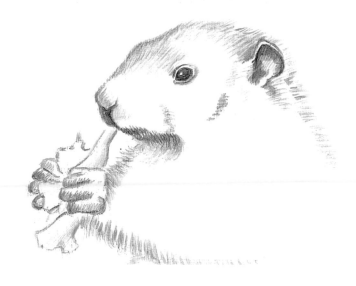

MATERIALS	
Colors	Titanium White
Burnt Sienna	Ultramarine Blue
Burnt Umber	
Cadmium	**Brushes**
Orange	no. 1 rounds
Raw Sienna	

STEP 1: *Establish Form*

Sketch the woodchuck lightly in pencil. Paint the main lines with Burnt Umber thinned with turpentine.

STEP 2: *Paint Darkest Value*

Mix the dark brown color for the shadows inside the ear and the darker fur around the ear with Burnt Umber and Ultramarine Blue. Paint with short, parallel brushstrokes inside the ear and longer parallel strokes for the fur around the ear.

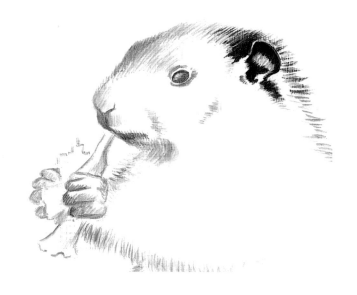

STEP 3: *Paint Middle Values and Highlights*

Mix the bluish color for inside the ear with Titanium White and small amounts of Ultramarine Blue and Raw Sienna. Blend the bluish color with the dark brown shadows inside the ear with separate brushes, painting small strokes into the edges of the colors. Mix the lighter color for the outer edge of the ear with Titanium White, Raw Sienna and small amounts of Cadmium Orange and Burnt Sienna. Use the same color mixture for the surrounding fur, following the way the fur grows. Blend the outer edge of the ear into the darkness inside the ear with small parallel strokes of the light color that overlap just the very edge of the dark color. Paint the light-colored tufts of fur at the base of the ear with the same brush.

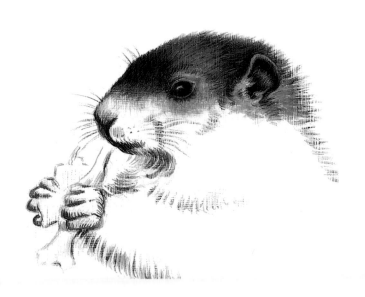

Woodchuck Nose and Whiskers

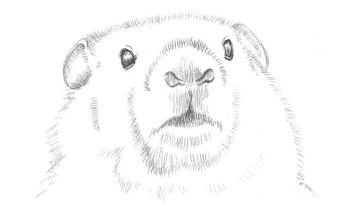

STEP 1: *Establish Form*

With a no. 2 pencil, lightly sketch the head. Use a sharpened Ebony pencil to sketch the main lines and shadow areas.

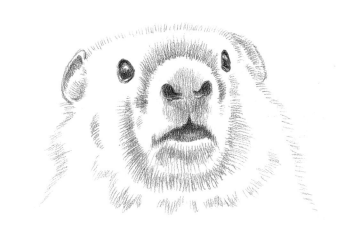

STEP 2: *Begin Shading Darker Areas*

Gradually begin to darken the mouth and nostrils using short, parallel pencil strokes, with moderate pressure on your pencil. Add more fur detail, being sure to use shading that follows the direction of the hair growth pattern.

STEP 3: *Shade to Darkest Value and Finish Details*

Continue shading, gradually increasing the pressure on your pencil until you have smooth dark areas that blend into the lighter areas. Draw more fur detail, using parallel pencil strokes that follow the fur pattern. Sharpen your pencil just before you render the whiskers. Using fairly light pressure on your pencil, draw a thin, curving line. Decrease pressure on the pencil as you go toward the end of the whisker, so the base will be darker and the whisker will gradually taper and become lighter toward the tip. Use your kneaded eraser to correct any mistakes or lighten areas that become too dark.

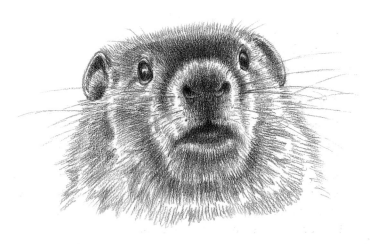

Woodchuck Feet
ACRYLIC ON ILLUSTRATION BOARD

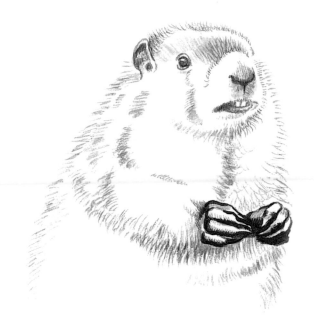

MATERIALS	
Colors	**Brushes**
Burnt Umber	no. 1 rounds
Titanium White	
Ultramarine Blue	

STEP 1: *Establish Form and Dark Values*

Sketch the woodchuck lightly in pencil. Paint the main lines with Burnt Umber thinned with water. Mix the black for the darkest part of the feet with Burnt Umber and Ultramarine Blue and paint with a small amount of water.

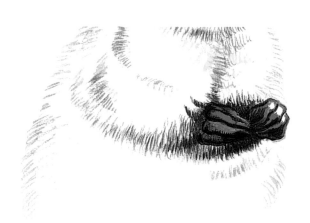

STEP 2: *Paint Middle Value*

Mix the bluish color for the middle value with Ultramarine Blue, Burnt Umber and Titanium White. With a separate brush and some of the dark color from step 1, begin to blend the two colors.

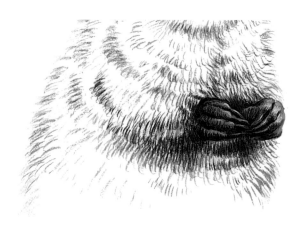

STEP 3: *Paint Highlights and Details*

Continue blending the middle and dark values. With the dark value, use small parallel brushstrokes that come up from the shadows between the toes and overlap the lower part of the bluish color. Mix a lighter value for the tops of the toes where light is falling on them by mixing a small amount of the middle value with some Titanium White. Use pure Titanium White to paint the brightest highlights on the claws and the tops of the toes.

Woodchuck

ACRYLIC ON ILLUSTRATION BOARD

MATERIALS

Colors	Brushes
Burnt Sienna	no. 0, 1 and 3
Burnt Umber	rounds
Raw Sienna	no. 2 filbert
Titanium White	
Ultramarine Blue	
Yellow Oxide	

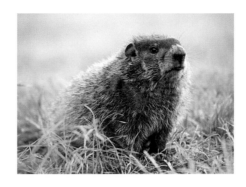

Reference Photo

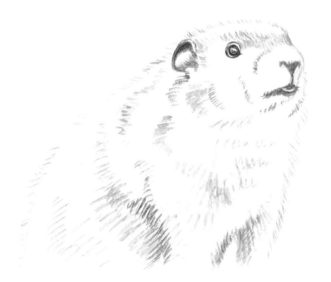

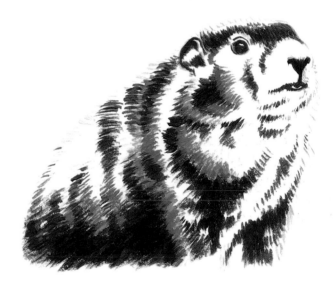

STEP 1: *Establish Form*

Sketch the woodchuck lightly in pencil. Paint the main lines and form with a no. 3 round and Burnt Umber thinned with water. (From now on, paint with a small to moderate amount of water on your brush, unless otherwise indicated.)

STEP 2: *Paint Darkest Values and Begin Middle Values*

Mix the dark brown for the darkest parts of the coat with Burnt Umber and a moderate amount of Ultramarine Blue. Paint with a no. 3 round. Paint the nose, mouth, inside the ear and the shadowed areas of fur, following the direction the fur grows. Paint the eye with a no. 1 round. Mix the brownish middle-value color with Titanium White, Raw Sienna and Burnt Sienna. Begin to paint this color with a no. 2 filbert.

STEP 3: *Paint Middle-Value Colors and Begin Highlights*

Continue painting the middle value with the no. 2 filbert, switching to a no. 3 round for the smaller areas around the eye, nose and mouth. Leave the lightest, highlighted parts of the coat white. As the paint dries, add more layers of paint until the surface is well covered. Then, use a no. 3 round to begin stroking some of the dark brown you mixed in step 2 from the dark areas out into the middle-value areas. Use the same brush and dark brown color to start adding smaller areas of dark fur over the brownish middle-value color.

Mix the bluish color for inside the ear, the top of the nose and the brow line with Titanium White, Ultramarine Blue and Burnt Umber. Paint with a no. 1 round, then use a separate no. 1 round and the dark brown color to stroke the edges, integrating the two colors. Mix the highlight color with Titanium White and a small amount of Yellow Oxide. Begin to paint highlights along the chest, head and front leg with a no. 1 round.

STEP 4: *Paint Details*

Continue to paint dark brown fur detail with a no. 1 round. Woodchucks have a brown coat that is sprinkled with light-colored hairs. Paint these hairs over the brown so that the brown coat underneath shows through between the brushstrokes. With a no. 1 round, paint the highlight color you mixed in step 3 along the woodchuck's back, fading gradually into the body. In the broad areas of dark brown, use a no. 1 round to paint hair detail with the brownish middle value you mixed in step 2. Then, with a separate no. 1 round, paint some of the highlight-colored hairs that are sprinkled over the coat. If they appear too bright, use the no. 1 round with some of the brownish middle-value color thinned with water to glaze over them.

Paint the eye highlight with a no. 1 round using a mixture of Titanium White and a touch of Ultramarine Blue. Make a small, curving brushstroke to show the roundness of the eyeball. Paint the whiskers overlapping the body (on the right side) with the dark brown color mixture from step 2 and a no. 0 round. Paint the whiskers overlapping your background with the highlight color and a separate no. 0 round, using enough water so the paint flows easily. Make corrections as needed by painting over a whisker with your surrounding color, then repainting.

5

FERRETS AND OTTERS

Ferrets and otters are playful, fun-loving animals.
Both are members of the weasel family and have
long, low-slung bodies, short legs and small,
rounded ears. This family also includes mink,
sables, badgers, wolverines, martens and skunks.

The ferret is the only domesticated member
of the weasel family. Originally, ferrets were used
to control rats and mice in granaries, but now
many are kept as pets. Ferrets love to play and are
very sociable. They have an undercoat of fine,
soft, short hair and an outer layer of longer,
coarser guard hairs. They come in various colors,
but most have a raccoon-like mask, and legs, tails
and ears that are darker than the rest of the body.

The North American river otter is one of
thirteen species of otters worldwide. It amuses
itself either alone or in groups by rolling, sliding
down snow or mud banks, and frolicking in the
water. The otter is an excellent swimmer, feeding
mainly on fish. Its thick, velvety fur ranges in
color from dark brown to reddish or grayish
brown, with lighter, silvery-colored hair on the
belly, throat and cheeks.

Ferret
Acrylic on illustration board
5½" × 10" (14cm × 25cm)
Collection of the artist

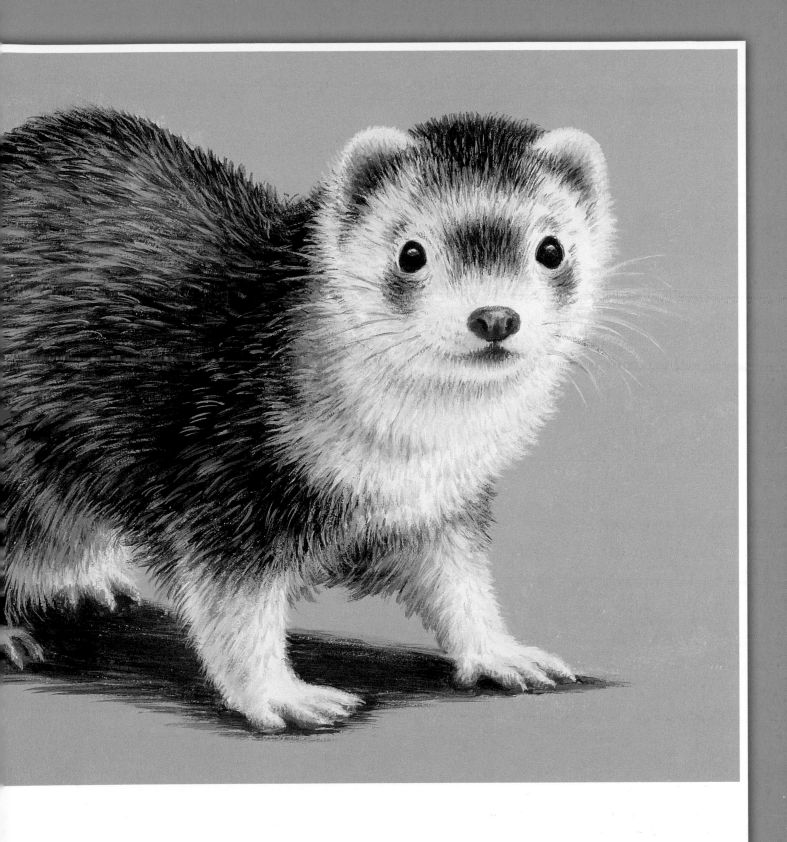

Typical Characteristics

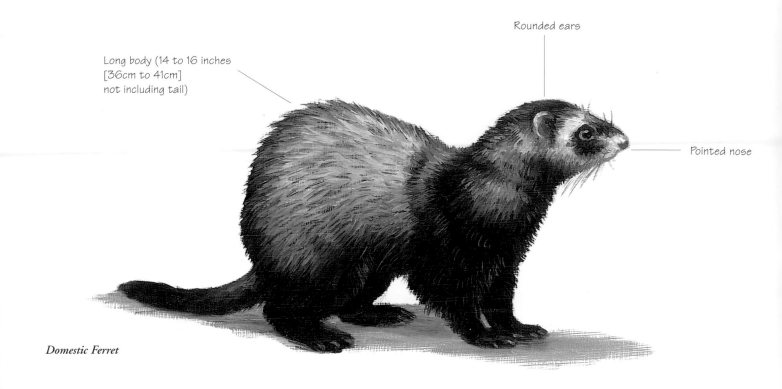

Rounded ears

Long body (14 to 16 inches
[36cm to 41cm]
not including tail)

Pointed nose

Domestic Ferret

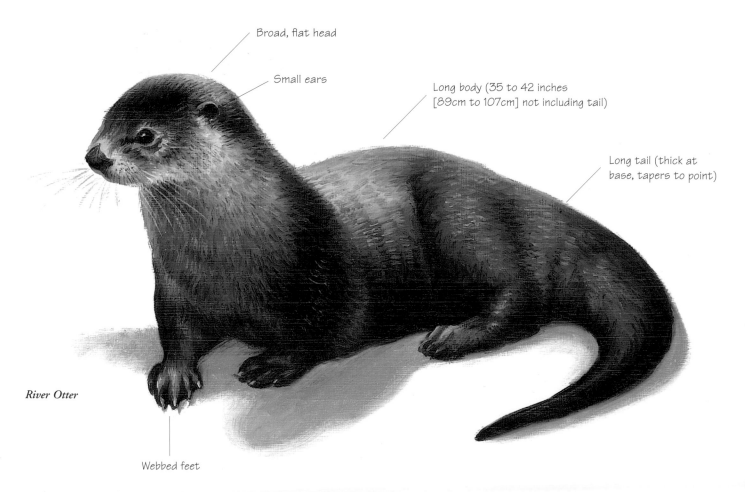

Broad, flat head

Small ears

Long body (35 to 42 inches
[89cm to 107cm] not including tail)

Long tail (thick at
base, tapers to point)

River Otter

Webbed feet

Ferret Eyes
ACRYLIC ON ILLUSTRATION BOARD

Colors	Brushes
Burnt Umber	no. 0, 1, 3 and 5
Scarlet Red	rounds
Titanium White	
Ultramarine Blue	
Yellow Oxide	

MATERIALS

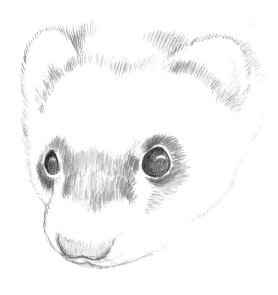

STEP 1: *Establish Eye Shape*

Lightly sketch the head in pencil. Paint the eyes with Burnt Umber thinned with water and a no. 3 round, leaving a white space for the highlight.

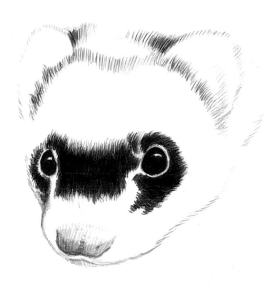

STEP 2: *Paint Dark Value of Eyes and Surrounding Fur*

Mix Burnt Umber and Ultramarine Blue for the dark brown eye color, and paint with a no. 3 round. As the paint dries, add more layers of color until the eye is nice and dark. Mix the fur color for the black mask surrounding the eyes with Burnt Umber and more Ultramarine Blue than you used for the eye. Paint with a no. 5 round, following the fur growth.

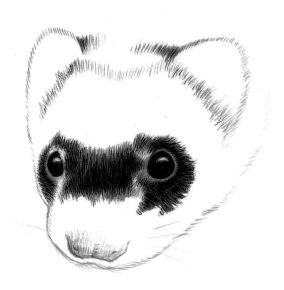

STEP 3: *Finish*

Paint around the eyes with a mix of Titanium White, Scarlet Red, Yellow Oxide and Burnt Umber and a no. 0 round. Using separate no. 0 rounds and the pinkish and dark brown fur colors, blend the edges of the pinkish line with small, overlapping strokes. Paint the fur highlights with a no. 5 round and a mix of Titanium White, Burnt Umber and Ultramarine Blue, toning them down as needed with a no. 3 round and the dark fur color. Use a no. 1 round and this color mixed with Titanium White for the eye highlights. Blend the edges.

Mix the white fur color with Titanium White and a touch of Yellow Oxide, and paint with a no. 1 round. Use separate no. 1 rounds for the dark fur color and the bluish color so you can blend where the white fur meets the dark fur.

Ferret Ears
OIL ON GESSO-PRIMED MASONITE

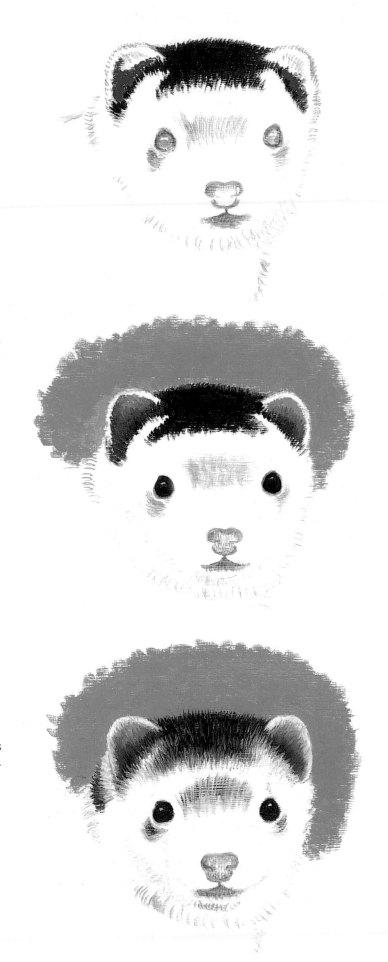

MATERIALS	
Colors	Titanium White
Burnt Sienna	Ultramarine Blue
Burnt Umber	
Cadmium Red	**Brushes**
Light	no. 0, 1 and 3
Cadmium Yellow	rounds
Light	no. 2 filbert
Raw Sienna	

STEP 1: *Establish Form and Dark Values*

Lightly sketch the head in pencil. With Burnt Umber thinned with turpentine and a no. 3 round, paint the main lines. Mix the dark gray fur color with Burnt Umber, Ultramarine Blue and a bit of Titanium White. Paint the fringe at the base of the ears and the fur between them with a no. 2 filbert.

Mix the dark pink color for inside the ears with Titanium White, Cadmium Red Light, Burnt Sienna and Raw Sienna. Paint with a no. 1 round, following the way the hair inside the ears grows.

STEP 2: *Add Middle-Value Ear Color*

Mix the lighter-value pink color for inside the ears by mixing a small amount of the dark pink color you mixed in step 1 with a little Titanium White and Raw Sienna. Paint with a no. 1 round. With separate no. 1 rounds for the dark pink and the light pink colors, blend the edges. Repeat until blended, but do not overblend.

STEP 3: *Add Lighter Values and Details*

Use no. 0 rounds to finish. For the white fur, mix Titanium White with a touch of Cadmium Yellow Light. Paint around the outer edges of the ears. Blend these edges with the pink color inside the ears by stroking white parallel lines from the outer edge toward the inner part of the ears. With a separate brush and the light pink color, blend from the inside up toward the outer edge.

Next, paint white fur around the edges of the dark fur, stroking the white up into the dark color to blend. When your brush gets too much of the dark color on it, wipe it on a paper towel. With the dark gray fur color, blend into the white fur.

Ferret Muzzle and Nose

ACRYLIC ON ILLUSTRATION BOARD

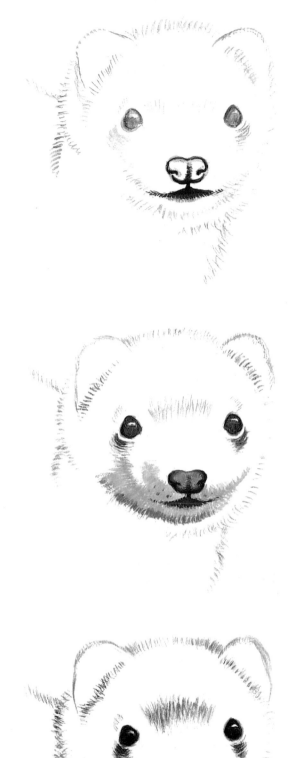

MATERIALS

Colors	Brushes
Burnt Sienna	no. 1 and 3
Burnt Umber	rounds
Scarlet Red	
Titanium White	
Ultramarine Blue	
Yellow Oxide	

STEP 1: *Establish Form and Darker Values*

Sketch the head lightly in pencil. Using a no. 3 round with Burnt Umber thinned with water, paint the main lines of the head. Mix the dark pinkish color for the dark parts of the nose and mouth with Scarlet Red, Burnt Umber and Titanium White. Paint with a no. 3 round. Using a no. 1 round, mix a little Burnt Umber and Scarlet Red, then paint the nostrils and the shadowed area of the nose. Darken the mouth shadow using small, parallel brushstrokes.

STEP 2: *Paint Middle Values*

Mix the middle-value pink color for the nose with Titanium White, Yellow Oxide, Scarlet Red and a little Burnt Sienna. Paint with a no. 1 round. With a separate no. 1 round and the dark-value pink from step 1, blend the edges where the darker and lighter colors meet.

Mix the bluish shadow color for the muzzle with Titanium White, Ultramarine Blue and a small amount of Burnt Sienna. Paint with a no. 1 round, stroking in the direction of fur growth. Mix the color for the shadow under the chin with Titanium White, Burnt Sienna and Burnt Umber. Paint with a no. 1 round.

STEP 3: *Add Lightest Values and Details*

Using separate no. 1 rounds, blend the edges where the bluish shadow of the muzzle fur meets the dark pinkish color of the mouth, and also where the bluish shadow meets the darker shadow under the chin. Mix the white fur color with Titanium White and a touch of Yellow Oxide. Paint with a no. 1 round, and blend by overlapping the edges of the bluish shadow. Paint nose highlights with some of the white fur color and a no. 1 round. Tone down these highlights with some of the pinkish middle-value color and a no. 1 round, using a drybrush technique.

Using a no. 1 round, paint the whiskers with some of the color you mixed for the shadow under the chin and more Titanium White, plus water.

Ferret Feet
GOUACHE ON ILLUSTRATION BOARD

MATERIALS	
Colors	Spectrum Yellow
Burnt Sienna	Ultramarine Blue
Burnt Umber	Zinc White
Cadmium Red	
Pale	**Brushes**
Cadmium Yellow	no. 1 and 3
Deep	rounds

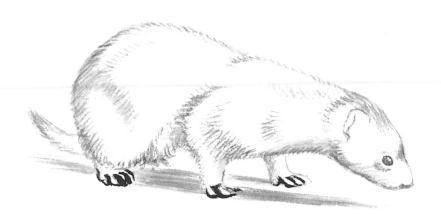

STEP 1: *Establish Basic Lines and Paint Darkest Values*

Sketch the ferret lightly in pencil. With Burnt Umber thinned with water and a no. 3 round, paint the main lines of the ferret. Mix the darkest value of the pink color for the feet with Zinc White, Cadmium Red Pale, Burnt Umber, and Burnt Sienna. Paint the shadows between the toes with a no. 1 round.

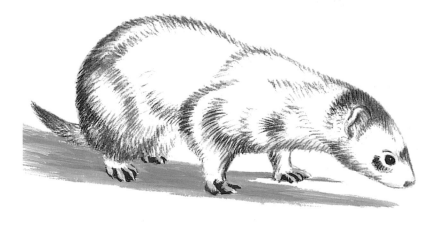

STEP 2: *Paint Middle Values*

Mix the middle-value pink color for the feet with Zinc White, Cadmium Red Pale and a small amount of Cadmium Yellow Deep. Paint the toes with a no. 1 round. For the ferret's shadow, use a mixture of Zinc White, Ultramarine Blue and a small amount of Burnt Umber. Paint with a no. 3 round, using horizontal brushstrokes.

STEP 3: *Blend Edges, Add Highlights and Finish*

With separate no. 1 rounds for the dark- and middle-value pink colors, blend the edges with small, overlapping strokes. Darken the shadows between the toes with an "accent" color mixed with Burnt Umber, Ultramarine Blue and a small amount of Zinc White. Paint with a no. 1 round. Paint the highlights on the toes and the toenails with Zinc White and a touch of Spectrum Yellow. Darken the shadow around the feet using some of the accent color and a no. 3 round, using horizontal brushstrokes that fade into the bluish shadow color.

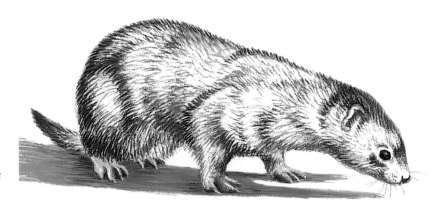

Ferret Tail
GOUACHE ON ILLUSTRATION BOARD

MATERIALS

Colors	Yellow Ochre
Burnt Umber	Zinc White
Cadmium Yellow	
Deep	**Brushes**
Spectrum Yellow	no. 3 rounds
Ultramarine Blue	

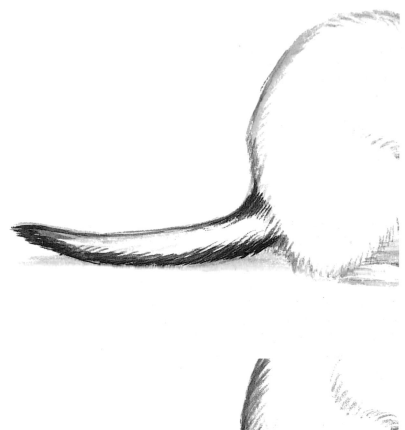

STEP 1: *Establish Main Lines and Paint Darkest Values*

Sketch the ferret lightly in pencil. Paint the main lines with Burnt Umber thinned with water. For the dark gray fur color, mix Burnt Umber, Ultramarine Blue and a small amount of Zinc White. Paint the darkest part of the tail using brushstrokes that follow the hair growth.

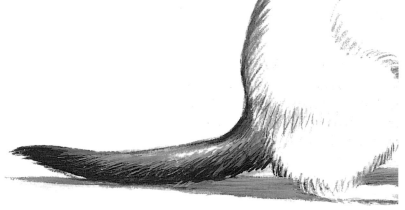

STEP 2: *Paint Middle Values*

Mix the warm middle-value color for the tail with Zinc White, Burnt Umber, Yellow Ochre and a small amount of Cadmium Yellow Deep. Paint using brushstrokes that follow the hair pattern and overlap the edges of the dark gray fur. Paint the ferret's shadow with a mixture of Zinc White, Ultramarine Blue and a bit of Burnt Umber. Use horizontal brushstrokes.

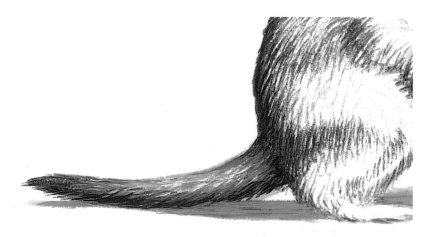

STEP 3: *Blend Edges, Add Highlights and Details*

Mix the highlight color with Zinc White with a touch of Yellow Ochre and Spectrum Yellow. Paint individual strokes that overlap the middle-value color and follow the hair growth pattern. With separate brushes for the dark gray color and for the warm middle-value color, reestablish these colors where needed, and blend.

Ferret
EBONY PENCIL ON ILLUSTRATION BOARD

STEP 1: *Establish Form
and Major Fur Patterns*

Sketch the ferret lightly with a no. 2
pencil. With an Ebony pencil sharp-
ened to a fine point, sketch the main
fur patterns, using parallel lines that
go in the direction of fur growth. Use
moderate pressure on the pencil.

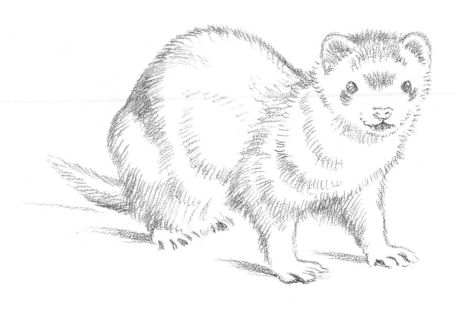

STEP 2: *Begin Darkening
Shadowed Areas*

Begin to shade the areas of darkest
fur, using pencil strokes that go in
the direction that you established in
step 1. Gradually increase the pressure
on your pencil as you shade. Gradual
shading will allow you to make correc-
tions more easily with your kneaded
eraser as the drawing progresses, and
will give you smoother tones.

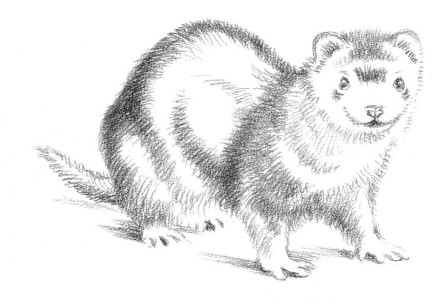

Step 3: *Continue Shading and Begin Details*

Continue to darken the shadowed and darker areas of fur, shading gradually to build up the dark value tones. Begin to add some fur detail in the lighter areas, using short, light-pressured pencil strokes.

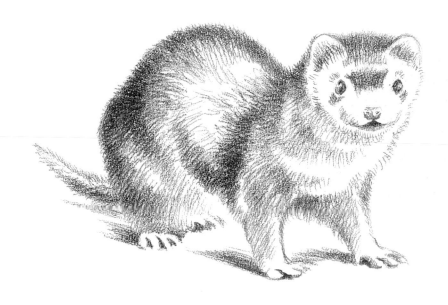

Step 4: *Finish Darkest Tones and Add Finer Details*

Keep shading the dark-value areas to their final darkness. Begin to add the finer details. For the whiskers, use a sharp pencil and lightly draw a long, curving single line. (If a whisker comes out too dark, lighten it with your kneaded eraser. Form the kneaded eraser into a point and lightly press down on the line.) Continue to add fur detail to the lighter areas, using short, staggered strokes that are roughly parallel and follow the fur growth.

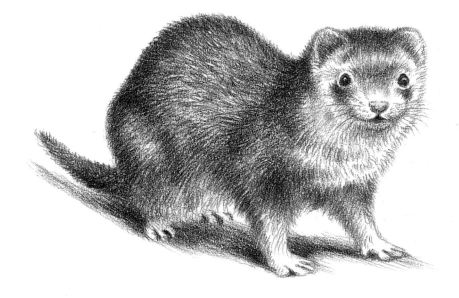

Otter Eyes
OIL ON GESSO-PRIMED MASONITE

MATERIALS

Colors	Titanium White
Burnt Sienna	Ultramarine Blue
Burnt Umber	
Cadmium	**Brushes**
Orange	no. 0, 1 and 3
Raw Sienna	rounds

STEP 1: *Define Eye Shape*

Lightly sketch the otter's head in pencil. With a no. 3
round and Burnt Umber thinned with turpentine, establish
the shape of the eye and the facial features.

STEP 2: *Paint Dark Value*

Mix the dark brown eye color with Burnt Umber and a
moderate amount of Ultramarine Blue. Paint the eye with
a no. 1 round. Leave a white space for the highlight. Use
the same brush and color to paint the dark fur around
the eyes.

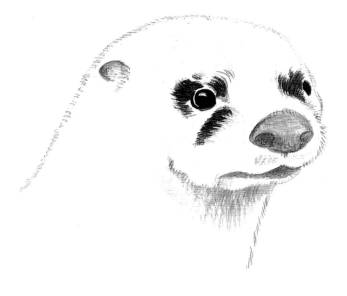

STEP 3: *Finish Fur Surrounding Eye and Add Highlight*

Mix the reddish brown color for above and below the
eye with Titanium White, Cadmium Orange and Burnt
Sienna. Paint with a no. 0 round. Mix the creamy fur color
for the cheek with Titanium White and Raw Sienna. Paint
with a no. 0 round. Using separate no. 1 rounds for the
three fur colors (dark brown, reddish brown and the
creamy color), blend the edges where these colors meet
using short, smooth strokes. Mix the eye highlight with
Titanium White and a touch of Ultramarine Blue. Paint
with a curving stroke with a no. 0 round.

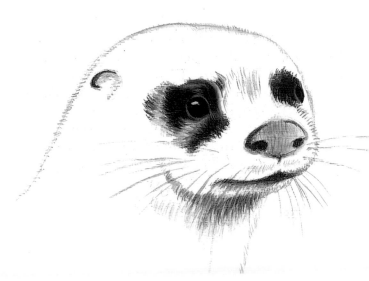

Mini-Demonstration

Otter Ears
ACRYLIC ON ILLUSTRATION BOARD

MATERIALS

Colors	Brushes
Burnt Sienna	no. 0, 1 and 3
Burnt Umber	rounds
Titanium White	
Ultramarine Blue	
Yellow Oxide	

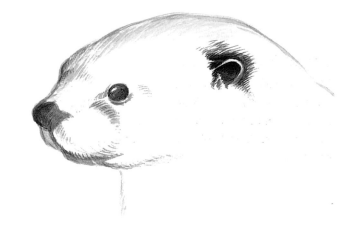

STEP 1: *Establish Ear Shape*

Sketch the otter's head lightly in pencil. With Burnt Umber thinned with water and a no. 3 round, paint the main lines and form of the ear.

STEP 2: *Paint Darkest Value*

Mix Burnt Umber and Ultramarine Blue for the dark brown inside the ear. Paint with a no. 0 round using small, parallel brushstrokes.

STEP 3: *Add Middle and Lighter Values*

Mix the highlight color for the outer edge of the ear with Titanium White, Yellow Oxide and a small amount of Burnt Sienna. Paint around the contour of the ear with a no. 1 round. Mix a darker version of this color by adding a little more Burnt Sienna. Paint the base of the ear with a no. 1 round. Make the outer edge of the ear look furry by using a no. 1 round and some of the highlight color to paint very small, parallel strokes that overlap the edge of the darkness inside the ear.

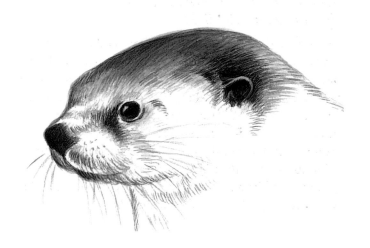

Otter Muzzle and Nose
OIL ON GESSO-PRIMED MASONITE

MATERIALS

Colors	Titanium White
Burnt Sienna	Ultramarine Blue
Burnt Umber	
Cadmium	**Brushes**
Orange	no. 1 and 3
Cadmium Yellow	rounds
Light	no. 2 filbert
Raw Sienna	

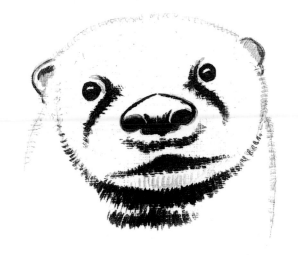

STEP 1: *Establish Form and Paint Dark Values*

Lightly sketch the head in pencil, then paint the main lines with a
no. 3 round and Burnt Umber thinned with turpentine. Mix the
dark brown color for the otter's fur with Burnt Umber and Ultra-
marine Blue. For the black nose, mix Burnt Umber with more
Ultramarine Blue than you used for the fur color. With separate
no. 3 rounds for each color, paint the dark parts of the nose and
muzzle. For the broader area under the chin, switch to a no. 2 filbert.
Use parallel strokes that follow the fur growth.

STEP 2: *Paint Middle Values*

Mix the bluish gray middle value for the nose with Ultramarine Blue,
Burnt Umber and Titanium White. Paint with a no. 3 round, then
use separate brushes to blend where the black and the bluish gray
meet. Mix the middle-value brown with Burnt Sienna, Cadmium
Orange, Titanium White and a moderate amount of Burnt Umber,
and paint with a no. 2 filbert. Begin to blend where the dark brown
fur meets the middle-value brown fur. Stroke the dark brown into
the edge of the middle-value brown with a no. 3 round, then use the
no. 2 filbert to stroke some of the lighter color into the dark.

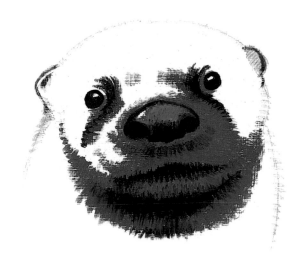

STEP 3: *Add Lighter Values and Details*

Mix the light creamy fur color with Titanium White and small
amounts of Cadmium Yellow Light and Raw Sienna. Paint with a
no. 3 round. Use separate brushes to blend the edges where the colors
meet. Add dark fur detail to the middle-value brown areas by paint-
ing strokes of the dark color over the brown. Using a no. 1 round,
paint the nose highlight with Titanium White and a small amount of
Cadmium Yellow Light. Paint the whiskers with two no. 1 rounds:
one for a light color to overlap the dark facial fur, and one for a dark-
er color overlapping the background. Mix the lighter whiskers with
Titanium White, a bit of Raw Sienna and a touch of Burnt Sienna.
Paint the whiskers overlapping the light fur and background with
some of the middle-value brown fur color and Titanium White.

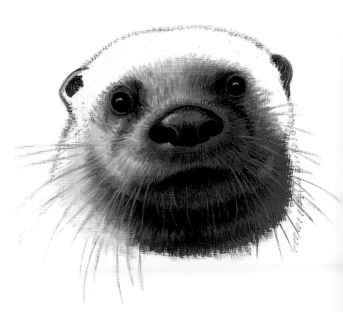

Otter Feet
ACRYLIC ON ILLUSTRATION BOARD

MATERIALS

Colors	Brushes
Burnt Umber	no. 0 and 3
Scarlet Red	rounds
Titanium White	
Ultramarine Blue	
Yellow Oxide	

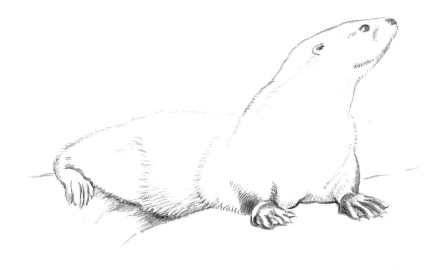

STEP 1: *Establish Basic Lines*

Sketch the otter lightly in pencil. Paint the main lines with Burnt Umber thinned with water and a no. 3 round.

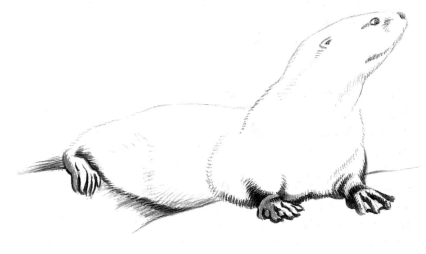

STEP 2: *Paint Dark Values and Begin Middle Value*

Mix Burnt Umber and Ultramarine Blue for the dark, shadowed parts of the otter's feet. Paint with a no. 0 round. Mix the bluish middle-value color with Titanium White, Burnt Umber and Ultramarine Blue. Begin to paint this color with a no. 0 round.

STEP 3: *Finish Middle Value, Blend and Add Details*

Finish with no. 0 rounds. Continue to paint the bluish color; then, with separate brushes, blend the edges where the two colors meet by painting small, fine, parallel strokes of the dark color so that it overlaps the edges of the bluish color. Then, blend back into the dark color with the bluish color. Paint the light pinkish toenails with Titanium White, Scarlet Red, Yellow Oxide and a small amount of Burnt Umber. Paint the highlights on the feet and toenails with Titanium White and a bit of Yellow Oxide.

Wet Otter Fur
ACRYLIC ON ILLUSTRATION BOARD

MATERIALS

Colors	Brushes
Burnt Sienna	no. 1 and 3
Burnt Umber	rounds
Raw Sienna	no. 2 filbert
Titanium White	
Ultramarine Blue	
Yellow Oxide	

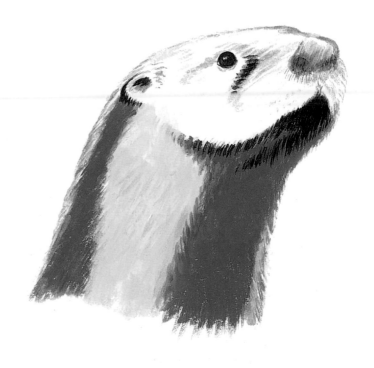

STEP 1: *Establish Form and Paint Basic Fur Colors*

Sketch the head and neck lightly in pencil. Paint the basic lines with a no. 3 round and Burnt Umber thinned with water. Mix the middle-value fur color with Titanium White, Raw Sienna and Burnt Sienna. Paint with a no. 2 filbert, switching to a no. 3 round for the smaller areas. For the dark brown fur color, mix Burnt Umber with a small amount of Ultramarine Blue. Paint the shadows under the chin with a no. 3 round, following the fur pattern. Mix the creamy color for the neck with Titanium White and a touch of Raw Sienna. Paint with a no. 2 filbert. For the line of reflected light on the throat, mix some of the middle-value fur color with a small amount of the creamy color. Paint with a no. 3 round.

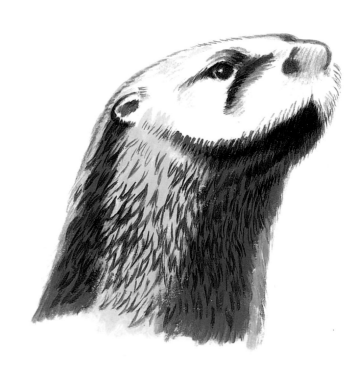

STEP 2: *Paint Shape and Shadows of Tufts of Wet Fur*

With a no. 3 round and the dark brown color you mixed in step 1 paint triangular-shaped shadows cast by wet hair tufts, making them curve slightly. Paint these shapes right over the base fur colors, following the overall hair pattern of the otter.

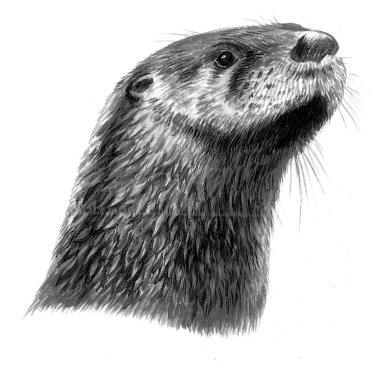

STEP 3: *Integrate Fur Tufts and Add Detail*

With a separate no. 3 round for each of the three fur colors
you have already mixed, begin to integrate the tufts. Soften
the sharpness and darkness of the shadows by painting over
them with strokes of the middle-value fur color. Use the
brush with the dark brown color to reestablish or add more
tufts as needed. Use the brush with the creamy fur color to
highlight the tufts. After you have painted tuft highlights
in the dark areas of the neck, integrate them by lightly
painting over the highlights with strokes of the middle-
value fur color. Add a few brighter highlights to the tips
of the tufts with a no. 1 round and some Titanium White
mixed with a touch of Yellow Oxide.

An Otter with Dry Fur
Notice that when an otter's fur
is dry, it is much smoother, and
doesn't have the triangular-shaped
tufts. To paint dry fur, use the
same colors and brushes, but use
thin, parallel strokes of paint that
follow the fur pattern. Integrate
the lighter areas with the darker
areas by stroking one color into
the adjoining color, using a sepa-
rate no. 3 round for each color.

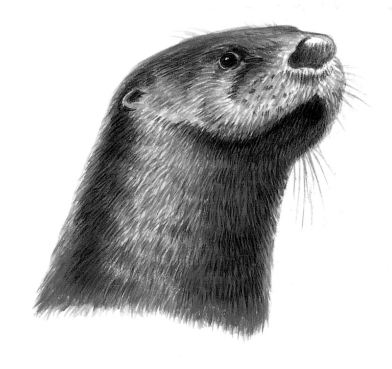

Otter
OIL ON GESSO-PRIMED MASONITE

MATERIALS

Colors Titanium White
Burnt Sienna Ultramarine Blue
Burnt Umber
Cadmium **Brushes**
 Orange no. 1 and 3
Cadmium Yellow rounds
 Light no. 2 filbert
Raw Sienna

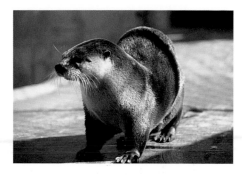

Reference Photo

STEP 1: *Establish Form and Basic Values*

Sketch the otter lightly in pencil. With Burnt Umber thinned with turpentine and a no. 3 round, paint the main lines and the shadowed areas of the otter.

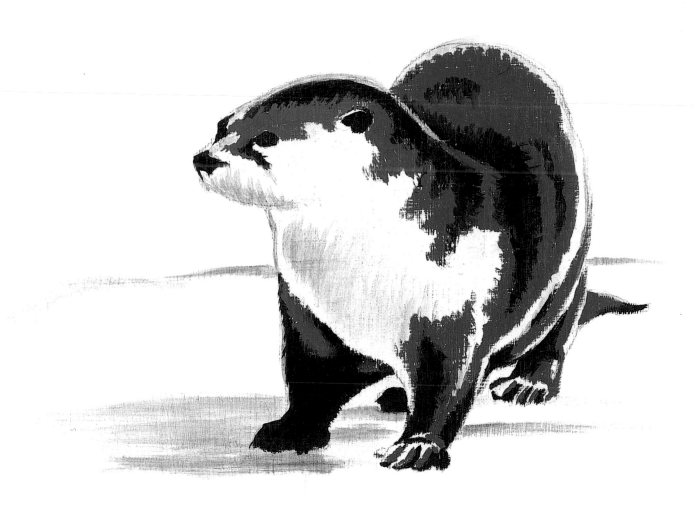

STEP 2: *Paint Dark and Middle-Value Brown Fur Colors*

Mix the dark brown fur color with Burnt Umber, Burnt Sienna and Ultra-marine Blue. With a no. 3 round, paint the darkest areas of fur. Use short, parallel brushstrokes that follow the general direction of fur growth. Mix the middle-value brown fur color with Burnt Sienna, Cadmium Orange, Titanium White and a moderate amount of Burnt Umber. Paint with a no. 3 round, using strokes that follow the fur pattern.

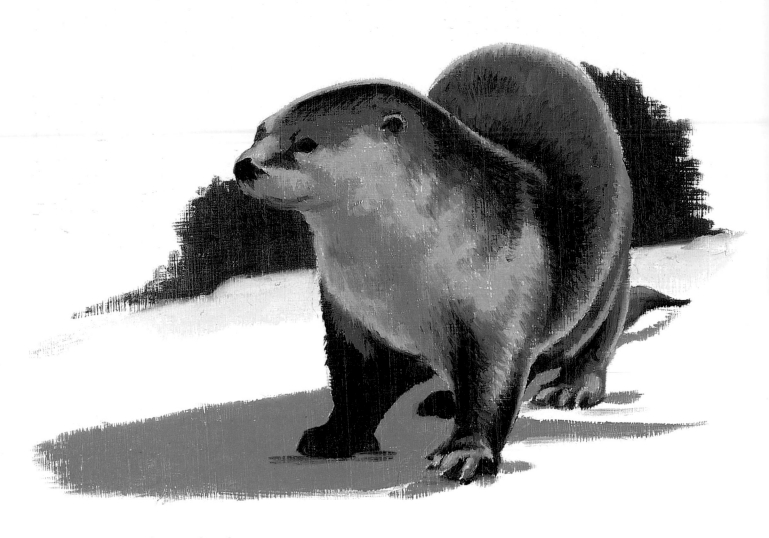

STEP 3: *Paint Lighter Colored Fur*

Mix the bluish shadow color for the underside of the muzzle and the chest with Titanium White, Ultramarine Blue and Burnt Umber. Paint with a no. 3 round, switching to a no. 2 filbert for the broader areas of the chest. Mix the paler tan fur color for the highlighted areas, the chest and belly with Titanium White, Raw Sienna and a small amount of Cadmium Orange. Paint with a no. 3 round. Using separate brushes for each of the four fur colors you have already mixed (dark brown, middle-value brown, bluish shadow color and tan color), begin to blend the edges where one color meets another. Hold all of your brushes while you work so you can easily switch from one to another. Blend with short, parallel strokes that follow the fur pattern.

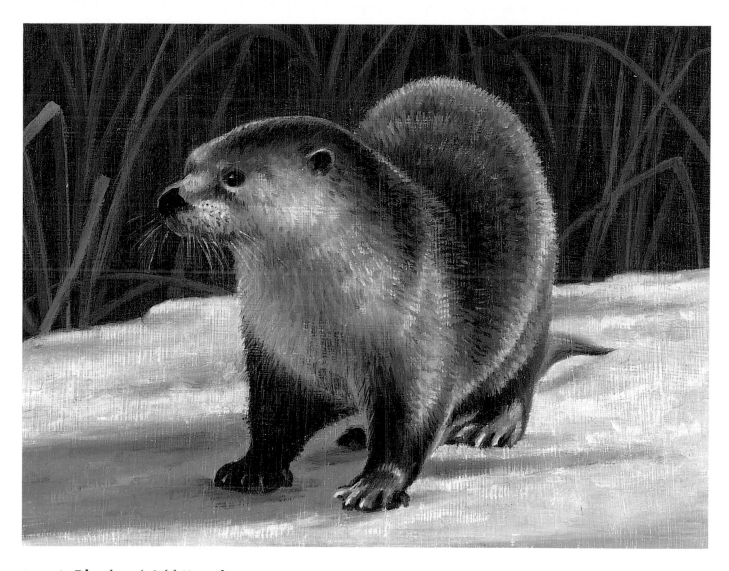

STEP 4: *Blend and Add Detail*

Add fur detail using separate no. 3 rounds for each color. Lightly paint short, parallel brushstrokes of dark brown over the bluish shadow on the chest. Use the same technique to add lighter fur detail by painting strokes of the tan color over the darker areas of fur, making sure to follow the hair pattern. Mix the fur highlight color with Titanium White and with a touch of Cadmium Yellow Light. Paint the highlights around the top of the head and back with a no. 1 round, painting a smooth, fine line around the contour. Then use small, parallel strokes to blend the edges.

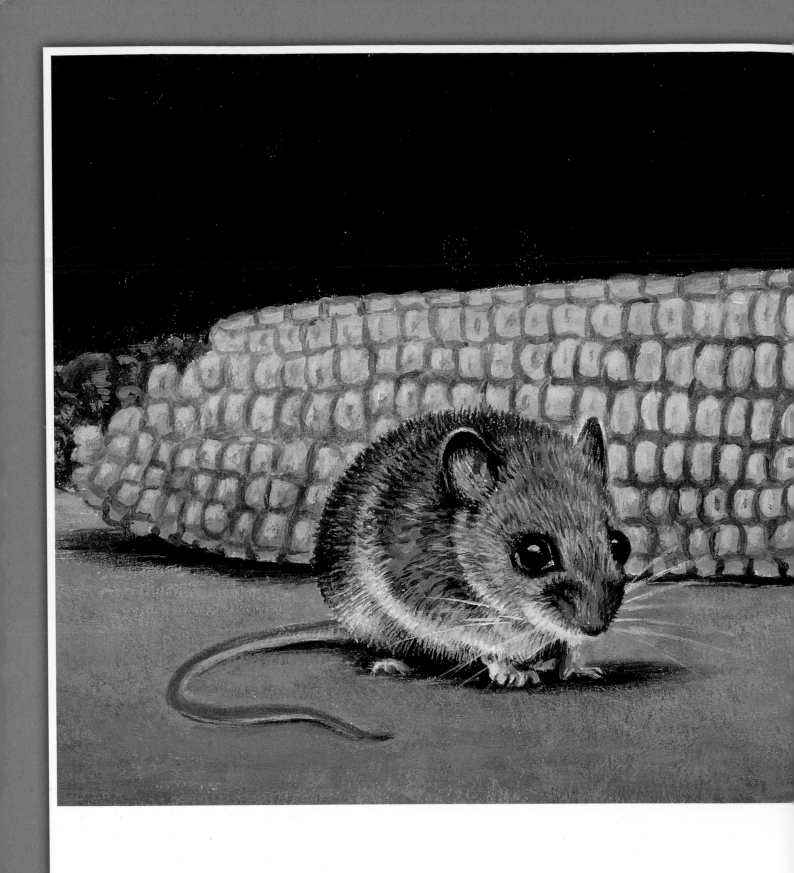

6

SMALL RODENTS

Templeton T. Mouse (detail)
Acrylic on illustration board
4½" × 12" (11cm × 30cm)
Collection of the artist

With the exception of the white-footed mouse, the small furry creatures in this chapter are all domesticated and commonly kept as pets. The white-footed mouse, the most common small rodent in North America, is primarily nocturnal and lives in abandoned bird nests, outbuildings and other animals' burrows. The golden hamster, native to Syria, comes in a variety of colors, is primarily nocturnal and stores food in its expandable cheek pouches to be eaten later. The type of gerbil commonly kept as a pet is the Mongolian gerbil. Gerbils look similar to rats but, unlike rats, have furry tails. Gerbils love to dig burrows, using their short, strong front claws to dig and their large hind feet to kick the dirt away. The domesticated guinea pig, a descendant of the wild guinea pig of central Chile, comes in a variety of coat types, colors and color patterns.

Small rodents should not be overlooked by artists who enjoy painting animals. Most of them are easy to find and make delightful subjects.

Typical Characteristics

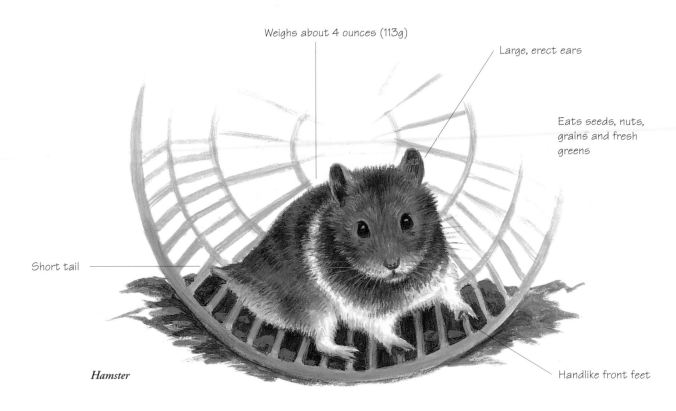

Weighs about 4 ounces (113g)

Large, erect ears

Eats seeds, nuts, grains and fresh greens

Short tail

Hamster

Handlike front feet

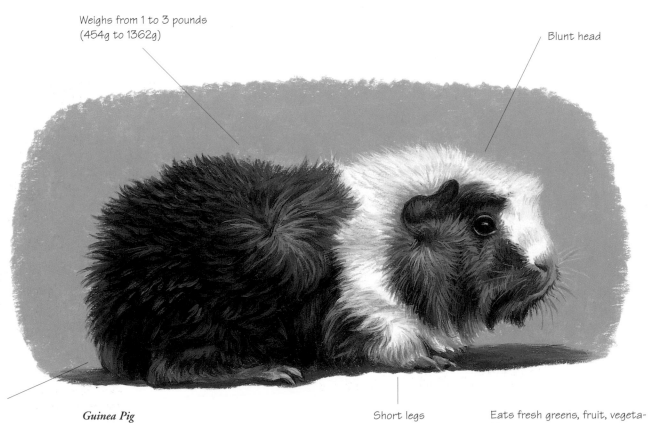

Weighs from 1 to 3 pounds (454g to 1362g)

Blunt head

No tail

Guinea Pig

Short legs

Eats fresh greens, fruit, vegetables, grain, seeds and hay

Brownish body with
white underparts

Large ears

Weighs from ⅜ to 1½ ounces
(11g to 43g)

Large eyes

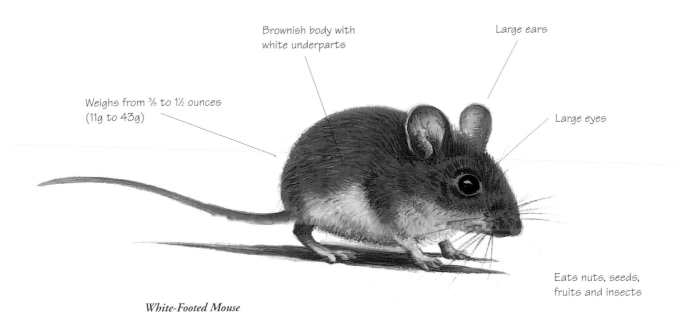

Eats nuts, seeds,
fruits and insects

White-Footed Mouse

Grayish or reddish
brown coat, white underneath

Straight, fur-covered tail

Almond-shaped eyes

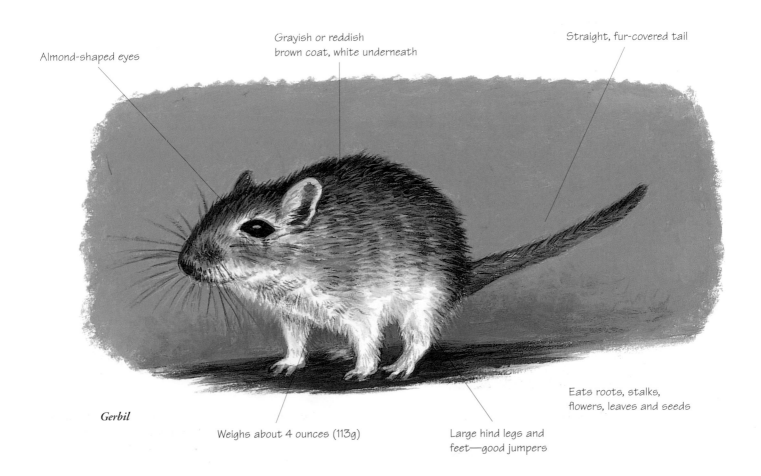

Eats roots, stalks,
flowers, leaves and seeds

Gerbil

Weighs about 4 ounces (113g)

Large hind legs and
feet—good jumpers

Teddy Bear Hamster
ACRYLIC ON ILLUSTRATION BOARD

MATERIALS

Colors
Burnt Sienna
Burnt Umber
Cadmium
 Orange
Hansa Yellow
 Light
Raw Sienna

Scarlet Red
Titanium White
Ultramarine Blue

Brushes
no. 0, 1 and 3
 rounds

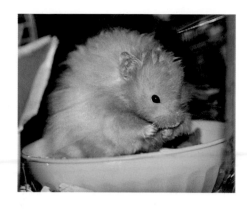

Reference Photo

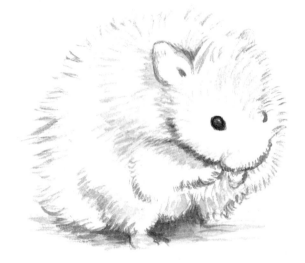

STEP 1: *Establish Basic Shape*

Sketch the hamster lightly in pencil. Use a no. 1 round and Burnt Umber thinned with water to paint the basic shape and indicate the areas of shadow. For the broader areas, use a no. 3 round.

STEP 2: *Paint Dark and Middle-Value Colors*

Mix the dark brown color for the eye and for the dark shadows under the nose and body with Burnt Umber, Burnt Sienna and a small amount of Ultramarine Blue. Paint with a no. 1 round. Mix the reddish brown color with Titanium White, Cadmium Orange, Burnt Sienna and Raw Sienna. With a no. 3 round, paint parallel brushstrokes that follow the hair growth pattern. Have enough water on your brush so that the paint flows freely but is not runny.

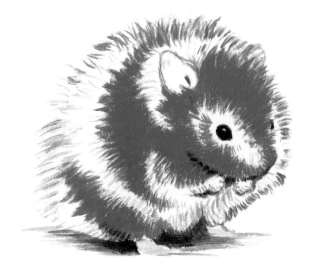

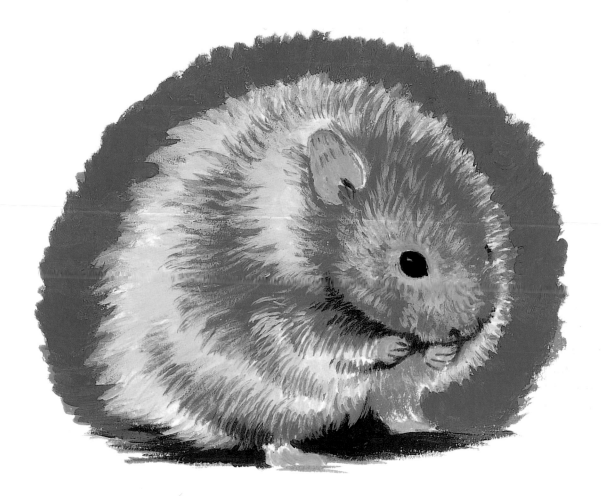

Step 3: *Begin to Paint Lighter-Value Colors*

Mix the pink color for the hamster's ears, feet, nose and around the eye using Titanium White, Scarlet Red and Raw Sienna. Paint with a no. 1 round. Reflect some of your background color (whatever you choose) into the fur. Here, I mixed a little of the blue background color with some Burnt Umber to create bluish shadows in the fur. Warm up and strengthen the dark brown shadows under the nose, jaw and front paws with Burnt Sienna and a no. 1 round.

Mix the buff fur color with Titanium White, Raw Sienna and a bit of Cadmium Orange. Paint with a no. 3 round, using enough water so the paint flows easily, following the fur pattern. Where the buff-colored fur overlaps the darker fur and the background color, use sweeping brushstrokes shaped like tufts of fur: roughly triangular, slightly curving and not all going in exactly the same direction.

Mix the hamster's shadow color with Ultramarine Blue, Burnt Umber, Burnt Sienna and a bit of Titanium White. Paint with a no. 3 round, using horizontal brushstrokes.

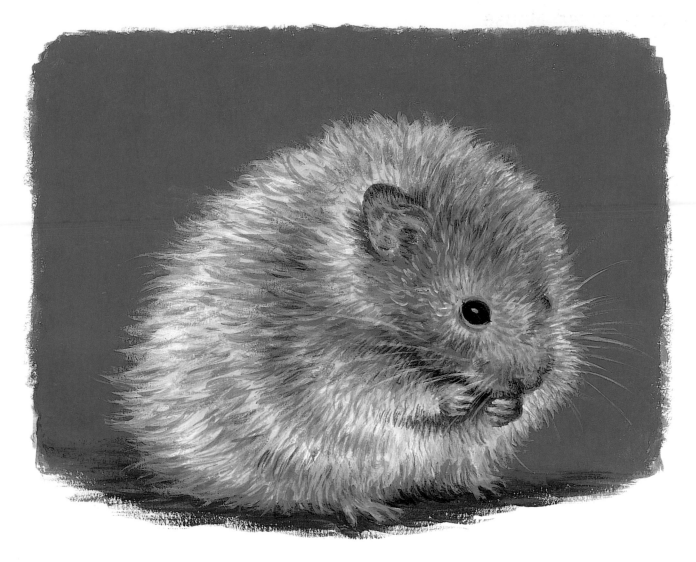

STEP 4: *Add Highlights and Details*

For the fur highlights, mix Titanium White with a touch of Hansa Yellow Light. Use a no. 3 round to paint tufts of wispy fur along the hamster's back into the dark background color. Vary the direction so the tufts are at different angles. With a separate no. 3 round and your background color, tone down or correct the shape of the tufts as needed. It will take more than one coat of paint to cover the background color so it doesn't show through the tufts. Continue to add fur detail to the coat with some of the reddish brown color you mixed in step 2. Thin this color with a little more water than usual so the color is more translucent against the buff fur.

Add lighter hairs to the face with a no. 0 round and some of the buff fur color. Paint with short strokes following the fur pattern. Add some darker shadows between the hair tufts on the body with a no. 1 round and some of the reddish brown fur color mixed with a little Burnt Sienna. Tone down and blend these shadows with a separate no. 1 round by painting over the dark areas with a light-pressured stroke and the reddish brown color.

Using a no. 0 round, paint the whiskers with the whitish highlight color you just mixed and some water. Lightly paint the whiskers with slightly curving, sweeping strokes. Correct or tone down any whiskers with a separate no. 1 round and the adjacent color. With a no. 0 round and small amounts of Titanium White and Ultramarine Blue, paint the eye highlight and a thin line for the lid underneath the eye. Add detail to the paws and the inside of the ears using no. 0 rounds for each value.

White-Footed Mouse
OIL ON CANVAS

MATERIALS

Colors	Payne's Gray
Burnt Sienna	Titanium White
Burnt Umber	Ultramarine Blue
Cadmium	
Orange	**Brushes**
Cadmium Red	no. 0, 1 and 3
Light	rounds
Cadmium Yellow	no. 2 filbert
Light	

Reference Photo

STEP 1: *Establish Main Lines and Values*

Sketch the mouse lightly in pencil, then use a kneaded eraser to lighten the lines so they won't show through the paint. Using a no. 3 round and Payne's Gray thinned with turpentine, paint in the basic form of the mouse.

STEP 2: *Paint Darkest Value Color*

Mix Burnt Umber and Ultramarine Blue for the dark brown fur color. Thin the paint with Liquin and use a no. 2 filbert for the broader areas and a no. 3 round for the smaller details. (From now on in this demo, use Liquin as your medium.) Vary the amount of medium you use to produce lighter and darker values.

For ease of blending in the next step, feather the edges of the dark fur rather than leaving an abrupt line between the painted and unpainted canvas.

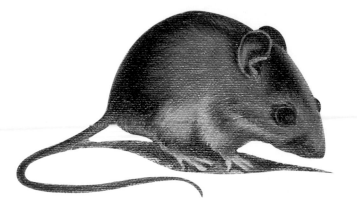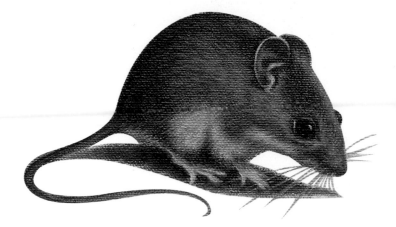

STEP 3: *Paint Middle-Value Colors*

Mix the reddish brown fur color with Cadmium Orange, Burnt Sienna and Titanium White. Paint with a no. 3 round, then, using separate no. 3 rounds, blend the edges of the darker and lighter fur. Blend alternately: first the middle, then the darker value, making sure that you paint the fur going in the direction of growth. Mix the bluish color for the lighter underbelly, detail around the eye and the ears of the mouse with Titanium White, Ultramarine Blue and a touch of Burnt Sienna to add warmth to the color. Paint with a no. 3 round, using a no. 0 round for around the eye. Mix the pinkish color for the feet with Cadmium Yellow Light, Titanium White and Cadmium Red Light. For shadowed areas of the feet, add a small amount of Burnt Sienna to the mixture.

Tip

In areas of dark fur that have some lighter hairs mixed in, paint in the whole area with the darker-value color first. The lighter hairs may be painted over the dark area later so that some of the dark fur still shows through.

STEP 4: *Add Highlights and Details*

When the painting is dry to the touch, add the highlights in the eye, around the edges of the ears and in the under-belly with Titanium White and a no. 0 round. After painting the underbelly highlights, use a separate no. 0 round with some of the bluish color you mixed in step 3 to lightly paint over and blend the highlights. Drybrush more muted, grayish highlights in the middle-value fur areas with a no. 1 round and the same bluish color.

Add some of the bluish color to the tail with the same brush, being careful not to cover all of the dark brown color. Reestablish the darks where needed with a no. 3 round and the dark brown color. Paint the whiskers with a no. 0 round and some of the bluish color, thinned with enough Liquin to create very thin lines. If a whisker is too dark or thick, carefully erase it with turpentine and a clean no. 1 round, then blot with a paper towel. Tone down whiskers that are too dark with a no. 0 round and a mixture of Liquin and Titanium White.

Tone down the edges of the shadow under the mouse using the drybrush technique with the bluish color and a no. 3 round, leaving the inner part of the shadow dark.

Gerbil
EBONY PENCIL ON BRISTOL BOARD

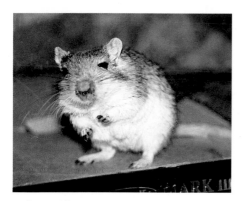

Reference Photo

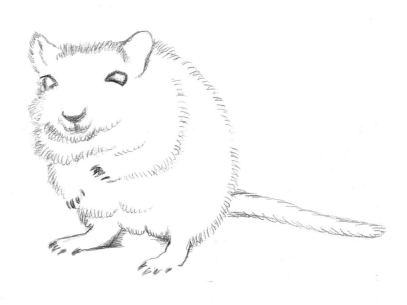

STEP 1: *Establish Main Lines*

With a no. 2 pencil, lightly sketch the gerbil. Press a kneaded eraser on the lines to lighten them. With an Ebony pencil sharpened to a fine point, establish the main lines of the gerbil with short, fine pencil strokes that follow the fur pattern.

STEP 2: *Begin Shading Darker Areas*

Begin to shade in the darkest areas of the fur with fairly short, parallel pencil lines that go in the general direction of fur growth. Shade in the eyes, leaving a white space for the highlight, and begin establishing the shadow with horizontal lines.

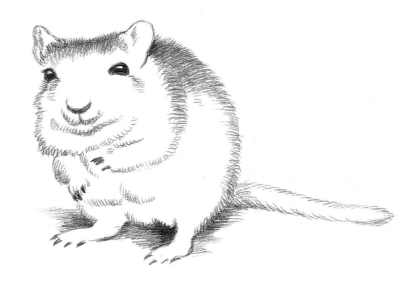

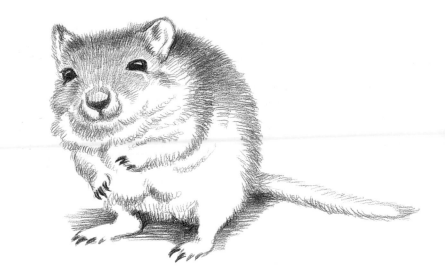

STEP 3: *Gradually Build Up Darker Value Areas*

Continue to shade the darker areas, using light-pressured pencil strokes except in the very dark areas: the claws, the eyes, behind the ear and the shadow around the feet. Keep in mind that gerbils are a light sandy color with white underneath, so you don't want to make the animal too dark overall.

STEP 4: *Continue to Darken Fur and Add Details to Lighter Areas*

Darken the fur on the head, back, and tail, gradually increasing the pressure of your pencil shading. Add detail to the white underbelly area using small, light-pressured, parallel strokes that follow the fur pattern. Draw the whiskers using a very sharp point on your pencil, and a moderate pressure to your strokes, which should curve downward and fade out toward the tips. To do this, gradually decrease the pressure on your pencil as you draw the whisker. Lighten any whiskers that come out too dark by pressing down on them with a kneaded eraser.

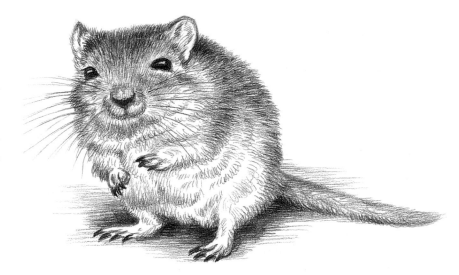

Tip

If you lift your pencil every time you make a stroke, you will create a linear effect of individual lines. Shading without lifting your pencil from the paper, but still making the strokes go in the same direction, creates a softer effect.

Abyssinian Guinea Pig
ACRYLIC ON ILLUSTRATION BOARD

MATERIALS

Colors	Titanium White
Burnt Sienna	Ultramarine Blue
Burnt Umber	
Cadmium	**Brushes**
Orange	no. 0, 1 and 3
Hansa Yellow	rounds
Light	no. 2 filbert
Raw Sienna	
Scarlet Red	

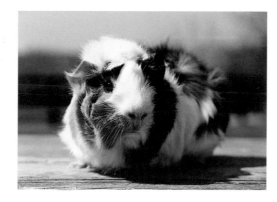

Reference Photo

STEP 1: *Establish Basic Form and Values*

Lightly sketch the guinea pig with your no. 2 pencil. To lighten any lines that come out too dark, press down on them with a kneaded eraser. Paint in the main lines and darker areas with Burnt Umber thinned with water. Use a no. 3 round for the broader areas and a no. 1 round for details such as the eyes, nostrils and mouth.

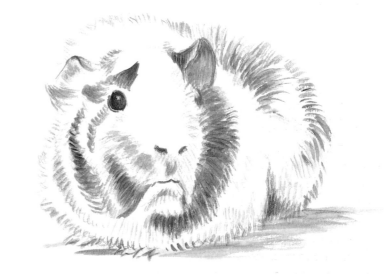

STEP 2: *Paint Darker Value Colors*

For the darkest parts of the coat and the cast shadow, use a no. 2 filbert with Burnt Umber, Burnt Sienna and Ultramarine Blue thinned with water, following the fur growth. For the finer areas, use a no. 3 round.

Mix the dark bluish color for the cast shadow with Ultramarine Blue, Burnt Umber, Burnt Sienna and a bit of Titanium White. Paint over the dark brown shadow with a no. 2 filbert. Use a no. 3 round around the toes and up into the shadow where the hind legs begin.

Mix the reddish brown fur color with Burnt Sienna, Cadmium Orange, Titanium White and Raw Sienna. Paint these areas with a no. 3 round. The Abyssinian guinea pig has harsh, wiry hair and has several circular patterns on its body, called *rosettes*, from which the hair swirls. Use a separate no. 3 round and the dark brown color to blend the dark fur into the reddish fur, using overlapping strokes.

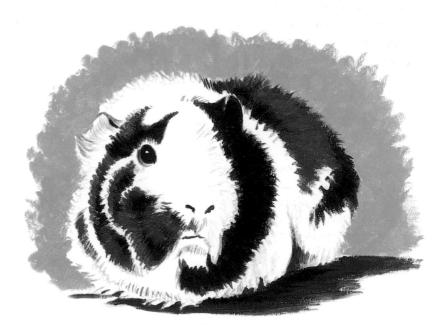

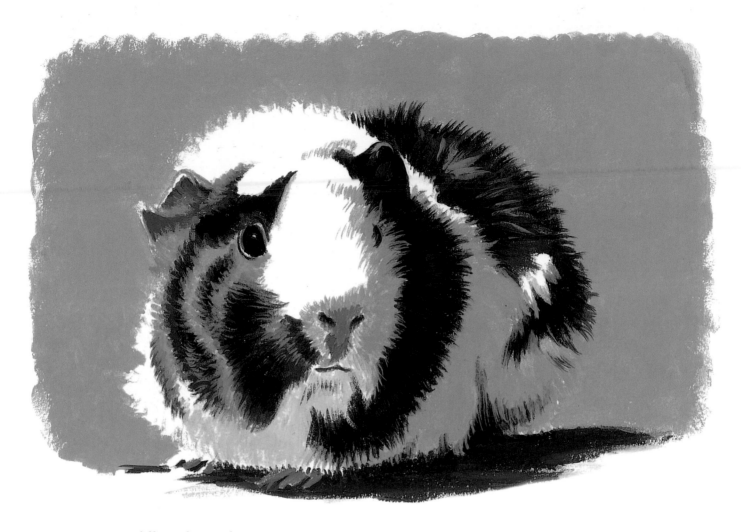

STEP 3: *Paint Middle-Value Colors*

Mix the bluish shadow color for the white parts of the coat with Titanium White, Ultramarine Blue and a small amount of Burnt Sienna. Paint with a no. 3 round, then use a separate no. 3 round for the dark brown and blend by stroking this color into and overlapping the edges of the bluish shadows. Make your strokes uneven to look like fur.

Mix the pink color for the nose and feet with Titanium White, Scarlet Red and a touch of Raw Sienna. Paint with a no. 1 round. Use a no. 1 round to paint the nostrils with some of the dark brown color thinned with water. For the darker pink inside of the right ear, mix a small amount of the pink color mixture with a bit of the reddish fur color, and paint with a no. 1 round.

Mix the warm buff color for the reflected light on the white part of the coat (under the chin) with Titanium White, Raw Sienna and a small amount of Cadmium Orange. Paint with a no. 3 round.

Mix the warm highlight color for the reddish fur with Titanium White, Cadmium Orange and Raw Sienna. Paint with a no. 3 round. With a no. 1 round and the color you just mixed, overlap the edges where they meet the darker color with small, roughly parallel brushstrokes, varying them slightly in length and spacing so they look like small tufts of fur.

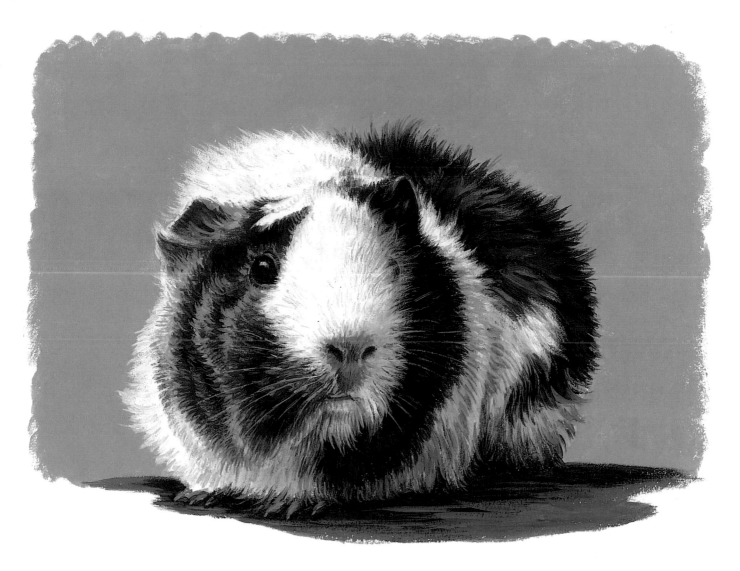

STEP 4: *Add Highlights and Finishing Details*

For the coat's white parts, use Titanium White and a little Hansa Yellow Light. Paint with a no. 3 round. Use this color and a no. 1 round to paint small tufts of hair overlapping where the white fur meets the darker colors. Blend with the adjoining color as needed.

For lighter detail in the bluish shadow areas, use a no. 3 round to mix some of the white mixture with a little of the bluish shadow color from step 3. Warm up the buff color under the chin by glazing it with a no. 3 round and Burnt Sienna thinned with water. Then, use some of the buff color to paint lighter hairs over it. Add highlights to the face with a no. 1 round and some of the warm highlight color from step 3 mixed with a little Titanium White.

Finish the shadow with the color you mixed in step 2 and a no. 3 round. Add a little Titanium White for the lighter edges of the shadows. Paint darker hair patterns in the shadow areas with a no. 1 round and some of the dark brown mixture thinned with water. Tone down and soften as needed with a separate no. 1 round and the bluish shadow color. Using a no. 1 round, darken the lower parts of the bluish shadow areas of the body with some of the dark bluish shadow color mixed with a little Titanium White.

Use no. 0 rounds to finish. With Titanium White and a touch of the bluish shadow color, paint the eye highlight and lines around the eye. Refine the toes with some of the dark bluish shadow color, and then the pinkish color. Paint the toenails with the warm highlight color you mixed for the fur in step 3. Paint the whiskers last. On the shadowed side of the face, use some of the bluish shadow color mixed with some Titanium White. On the highlighted side of the nose, use Titanium White.

conclusion

Although it was a tremendous amount of work, I had a lot of fun writing this book. I enjoy drawing and painting any kind of creature (I have portrayed everything from insects to dinosaurs), and this book allowed me to focus on some charming and interesting animals. Finding these animals to model for me was often a challenge, but it was also quite enjoyable. I met some nice people who shared my love for animals, and I also met some likeable animals! During my research, I learned a lot about the small animals included in this book, and I've tried to pass on this information to you.

Unlike some artists I've met who carefully guard their techniques, I've always felt that I should pass along anything I've learned to fellow artists. Certainly, I've learned from other artists—from studying Old Masters' paintings in museums, from talking with other artists at shows and from my artist friends. In the past, student artists learned by copying the paintings of the Old Masters, and I've also done this. I've learned a lot about how those artists achieved the effects I've admired.

I always try to answer the questions of other artists I meet who are interested in my technique. In this book, I've tried to tell you everything I can to help you paint small animals successfully. I hope you have enjoyed painting them as much as I did!

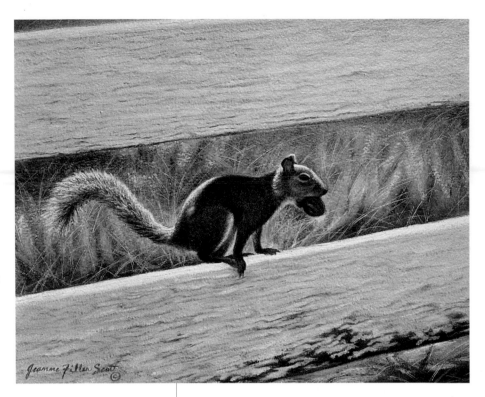

The Prize
Oil on panel
8" × 10" (20cm × 25cm)
Collection of the artist

index

Create extraordinary wildlife art

WITH NORTH LIGHT BOOKS!

Cynthie Fisher helps you paint realistic deer, antelope and more with straightforward instruction drawn from years of wildlife painting experience and zoological training. You'll find a detailed review of anatomy along with instructions for capturing the fine details of fur, antlers and facial features, plus proper use of color, texture, composition and light.

1-58180-021-5, paperback, 128 pages, #31656-K

Rod Lawrence provides you with the knowledge you need to paint over 15 waterfowl and wading birds, including mallards, white ibis, willets, heron, northern shovelers, Canadian geese and more. You'll master everything from avian body shapes and proportions to colors and habitats. Additional instructions help you reproduce realistic plumage.

1-58180-022-3, paperback, 128 pages, #31657-K

Wolves and foxes are a source of endless artistic inspiration and wonder. Learn how to capture these beautiful creatures and their kin in their natural habitats. Twelve step-by-step mini-demos and three full-size demonstrations show you how, with invaluable techniques for rendering fur, eyes, musculature and other distinctive features.

1-58180-051-7, paperback, 128 pages, #31839-K

Through step-by-step demonstrations and magnificent paintings, Patrick Seslar reveals how to turn oils, watercolors, acrylics or pastels into creatures with fur, feathers or scales. You'll find instructions for researching your subject and their natural habitat, using light and color and capturing realistic animal textures.

1-58180-086-X, paperback, 144 pages, #31686-K

Discover a wealth of crisp, gorgeous photos that you'll refer to for years to come. Each bird is shown from a variety of perspectives, revealing their unique forms and characteristics, including wing, feather, claw and beak details. Four painting demos illustrate how to use these photos to create your own compositions.

0-89134-859-X, hardcover, 144 pages, #31352-K

Capture your favorite animals up close and personal—including bears, wolves, jaguar, elk, white-tailed deer, foxes, chipmunks, eagles and more! Kalon Baughan and Bart Rulon show you how, providing invaluable advice for painting realistic anatomies, colors and textures in 18 step-by-step demos.

0-89134-962-6, hardcover, 128 pages, #31523-K

These books and other fine North Light titles are available from your local art & craft retailer, bookstore, online supplier or by calling 1-800-221-5831.